IMAGES
of America

JEWISH WEST VIRGINIA

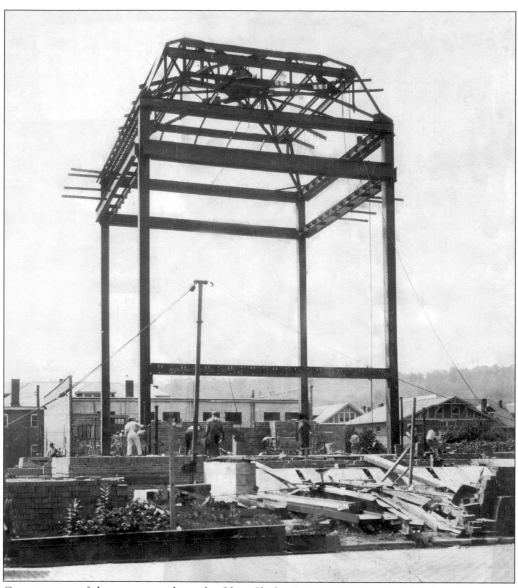

Construction of the sanctuary dome for Ohev Sholom's new synagogue in Huntington was well underway in this 1925 view. The Byzantine Revival–style synagogue was completed in 1926 and is one of the largest houses of worship in the state. It is the only synagogue in West Virginia to be listed on the National Register of Historic Places. (Courtesy of B'nai Sholom Congregation.)

On the Cover: The Temple Youth Group of Bluefield's Ahavath Sholom Congregation held a special dinner at the West Virginian Hotel in Bluefield in this late-1940s photograph. Temple and synagogue youth groups were an active part of Jewish community life in West Virginia, and provided social events, dinner, and religious activities within a Jewish framework. (Courtesy of Congregation Ahavath Shalom.)

IMAGES
of America

JEWISH WEST VIRGINIA

Julian H. Preisler

ARCADIA
PUBLISHING

Published by Arcadia Publishing
Charleston SC, Chicago IL, Portsmouth NH, San Francisco CA

Printed in the United States of America

Library of Congress Control Number: 2010920264

For all general information contact Arcadia Publishing at:
Telephone 843-853-2070
Fax 843-853-0044
E-mail sales@arcadiapublishing.com
For customer service and orders:
Toll-Free 1-888-313-2665

Visit us on the Internet at www.arcadiapublishing.com

Dedicated to the Jewish people of West Virginia, past and
present. They persevered and prospered, and helped to promote
religious and ethnic tolerance, understanding, and respect.

CONTENTS

ACKNOWLEDGMENTS

I began researching West Virginia's Jewish history shortly after moving to the state over five years ago. What I discovered was an amazing and rich history for such a small Jewish community. I then began work on a website devoted to the history of the Jewish community of West Virginia and this book is an outgrowth of that website. A book such as this relies heavily on the willingness of people to share their lives, experiences, and cherished family photographs. For some locations it was nearly impossible to obtain vintage images for use in this book. I have included a collection of images based on what I found and what was made available to me.

I could not have completed such an important piece of work without the help of many wonderful people. I would like to extend a very special "thank you" to Lynne Mayer of Huntington's Ohev Sholom Congregation. Her interest and assistance in obtaining important images for this book were a tremendous help to me. The members of the Bluefield-Princeton Jewish community, especially their synagogue president, Phyllis Horwitz, welcomed me to Bluefield and provided photographs, resources, and encouragement. Philip Angel Jr. and Betsy Gooding of Temple Israel in Charleston were most gracious in taking time to share photographs and stories with me when I visited there. Georgia Katz DeYoung and Aaron Z. Snyder, both formerly of Martinsburg, provided rare photographs to help represent the former Jewish community of Martinsburg. Marcia Jo Zerivitz of Florida's Jewish Museum was very helpful in providing many images relating to her life growing up in Charleston and the B'nai Jacob Congregation. Paul Borelli of Artcraft Studio in Parkersburg was instrumental in providing photographs to help illustrate Parkersburg's Jewish community.

In addition, I would like to thank Tom Broh, Bonnie Greenberg, William Hark, Margie Kakara, Myla Kreinik, Kevin Levine, Jeff Miller, Stanley Nelson, Shari Pepper, Sherry Rosen, Sharon Shapiro, Sue Tomchin, Joan Weisberg, and Deborah Weiner for all their interest and work which helped me to assemble a wonderful collection of photographs. To all who provided photographs, historical information, and helpful contacts I extend my sincere appreciation.

INTRODUCTION

The first official Jewish organization in West Virginia was a Jewish burial society established in Wheeling in 1849 by a small group of German-Jewish immigrants. A few Jews lived and traded in what is now West Virginia on a temporary basis as early as the late 18th century, but it was not until around 1843 that Alexander Heyman of Wheeling is documented as making West Virginia his permanent home. By 1846 there were apparently enough Jewish residents (minimum ten men for a religious quorum for communal prayer) to hold religious services for the High Holy Days as reported in *The Occident* Jewish newspaper. The official community did not get its start until the small group in Wheeling decided to procure land for Jewish burials, organize a burial society, and shortly thereafter organize the first Jewish congregation in the state, Congregation L'Shem Shomayim (For the Sake of Heaven). An earlier Jewish burial ground was begun in Charleston in 1836, but the B'nai Israel Congregation in Charleston was only informally organized in 1856 and not legally chartered by the state as the "Hebrew Educational Society" until 1873. The Charleston cemetery and religious group is today's Temple Israel. Wheeling's Congregation L'Shem Shomayim is today's Temple Shalom.

Because there were good retail and merchant opportunities in Wheeling, the Jewish community grew quickly. Family members from Europe and from other parts of the United States were encouraged to settle in Wheeling by their relatives already living in the state. As various industries, especially coal mining, grew in West Virginia, opportunities for work and advancement, primarily as merchants and retailers, became plentiful. This was the primary reason more Jews came to West Virginia and settled in a variety of small towns and cities throughout the state.

As the Jewish population grew, the need for communal and religious organizations became more apparent. Jewish Communities were established throughout the state in Beckley, Bluefield, Charleston, Clarksburg, Fairmont, Huntington, Keystone, Kimball, Logan, Martinsburg, Morgantown, Parkersburg, Weirton, Welch, Wheeling, and Williamson. In addition, small numbers of Jews also settled in the towns of Grafton, Harper's Ferry, Keyser, Montgomery, Mount Hope, Oak Hill, Piedmont, Romney, Thomas, and other locations. Though their population numbers in these towns were never high enough to warrant establishing formal congregations, many formed local chapters of Jewish fraternal and charitable groups such as B'nai B'rith and Hadassah. In the larger Jewish communities of Wheeling, Huntington, and Charleston, members of the Jewish community helped to organize social and business clubs. Jews were also members of the established fraternal, commerce, and community groups in each community.

The Jews of West Virginia have, since they began settling in the state, been involved in all aspects of wholesaling and retailing. In most cities and many of the small towns, a large percentage of the stores were Jewish owned and operated. Jewish names were found on retail businesses throughout the state. It was not uncommon for the few Jewish residents of a small town to be well-known and respected. In some cases these were the first Jews that the towns' predominantly Gentile populations ever met. Jews also were involved in manufacturing and distribution, but on a smaller

scale than their representation in the retail sector. Jewish pharmacists, doctors, attorneys, and dentists could also be found, even in some of the small towns. As the various Jewish communities grew and generations became settled and prosperous, Jews in West Virginia became very active in all aspects of life in the state including commerce, culture, politics, philanthropy, and even sports. West Virginia Jews have always fiercely defended their state and because West Virginia has been good to them, they are eager to give back as much as they can and promote all that is good in the state.

The Jewish population of the state has declined over the last 30 years due to declines in industry in the state and because of changing retail and business patterns. As many families prospered in business and were able to send their children to college, many did not return to West Virginia, preferring to live in larger and less isolated Jewish communities in other states. This was not always the case though, and many young people returned to West Virginia to raise families and continue a family business or strike out in their own careers. Today, dedicated Jewish communities can still be found in many areas of the state. Larger Jewish communities exist in Charleston, Huntington, and Morgantown, with smaller Jewish communities in Beckley, Bluefield, Parkersburg, and Wheeling. Charleston has a reform temple and a Traditional synagogue. It is the largest Jewish community in the state and has a stable community life with diverse religious services and a variety of Jewish community organizations. Temple Israel and B'nai Jacob Synagogue are well recognized institutions in the city. Huntington has a magnificent and historic synagogue building, several auxiliary Jewish organizations, and continued Jewish involvement in civic and business life in the city. The Tree of Life Synagogue in Morgantown is growing because of its location near West Virginia University. Morgantown is the only college or university in the state to have a local chapter of Hillel, the Jewish student group associated with B'nai B'rith.

West Virginia possesses a rich and varied Jewish past and a hopeful Jewish future. The Jewish population of the state supports a variety of synagogues, temples, and Jewish social and charitable organizations. There are landmark synagogues, famous and historic businesses, cemeteries, and many notable Jewish families with a long history in the state. The following pages provide a glimpse into that history.

One

BECKLEY AND
BLUEFIELD-PRINCETON

Jews settled in Beckley in the early 1900s. In 1921 a Jewish religious school was organized and the first religious services were held. In 1935 the Beth El congregation was formed by Samuel I. Abrams, Nathan Berman, Louis J. Fink, Irving Goldstein, William Klein, James Pickus, Louis Pickus, Nathan Pickus, Abe Saks, and Jacob Silverberg. A temple was built in 1936 at Belleview Lane and Second Street. Jewish organizations in Beckley included a sisterhood, men's club, temple youth group, junior congregation, a Hadassah chapter, and B'nai B'rith Lodge 1360. A Jewish cemetery was dedicated in the mid-1950s.

Most of Beckley's Jews were engaged in retailing. Notable stores included Pickus Department Store, Modern Furniture Company, Union Furniture Store, People's Credit Clothing, Cavalier Cut Rate Store, the Hub and Vogue stores, Harry's Men's Shop, Quality Shop, Eppy's Drug Store, and others. A remaining Jewish-owned store is Best Fabric and Foam. Tom Sopher owns the business started by his father Ira in 1943. Tom is an active leader of Beth El Congregation. In the 1950s, there were nearly 70 Jewish families in Beckley. The synagogue continues to serve the needs of a much smaller Jewish population.

Jews settled in Bluefield in the early 1900s, and in 1902 the Bluefield synagogue, Ahavath Sholom, was formed. The founders were I. Aaron, Jacob and Simon Baker, Barney and Isaac Cohen, Saul and Solomon Greenspon, Louis Kaufman, Samuel Matz, Henry Rodgin, and Samuel and Saul Turk. Their first permanent synagogue was the former Scott Street Presbyterian Church dedicated in 1907. The congregation dedicated their new synagogue on Albemarle Street in 1949. Active community groups included the temple sisterhood and youth group, B'nai B'rith Lodge, United Jewish Charities of Bluefield-Princeton, and Hadassah. A Jewish cemetery section exists at the Monte Vista Park Cemetery.

Bluefield's Jews were also mostly engaged in retailing. Some of the earliest Jewish businesses in town were those of Isadore Cohen, Nathan Platnick, Henry Rodgin, Morris Rosenberg, and Samuel Turk. One of the last Jewish businesses in the city is Kammer Furniture, established in 1932. Dr. Rodgin is an optometrist in town whose family was one of the earliest in Bluefield. Bluefield's Jews were also doctors and attorneys. Bluefield had a large Jewish community for many years, and it was involved in all aspects of city life. The Jewish community today is much smaller, but is an active congregation.

Princeton also had Jewish families and an informal Jewish congregation. Jewish businesses included those of the Barbakow, Baum, Deitz, Lisagore, Nelson, and Tomchin families. By the 1950s, the Princeton and Bluefield Jews merged into one united community.

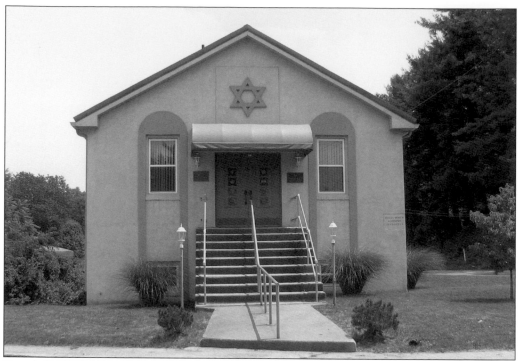

Temple Beth El was built in Beckley in 1935–1936 and was completely refurbished and renovated in the late 1990s. The temple, which is also known as the Beth El Hebrew Association, still serves a very small, but dedicated, Jewish congregation. (Author's collection.)

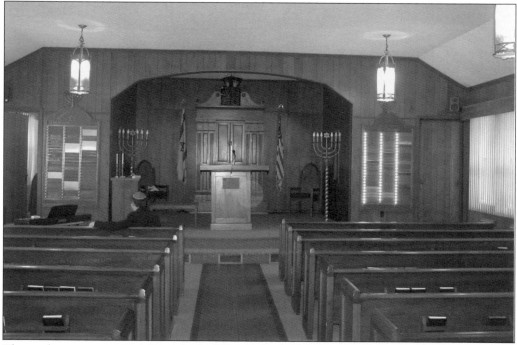

The modest sanctuary interior and ark of Temple Beth El appears much as it did when it was built, except for the addition of wood paneling around the ark. (Courtesy of Rabbi Josh Franklin.)

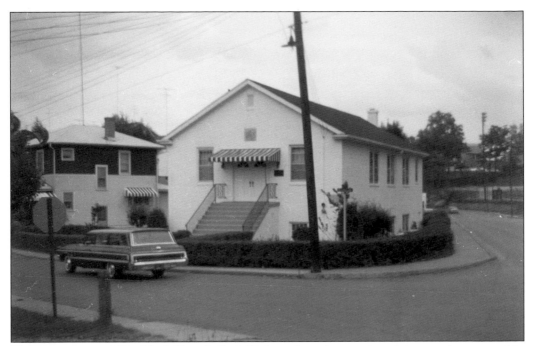

This vintage view of Beckley's Temple Beth El shows how the exterior of the temple appeared in the 1960s. The building has been altered only slightly since 1936 when it was originally dedicated. (Courtesy of Jeff Miller.)

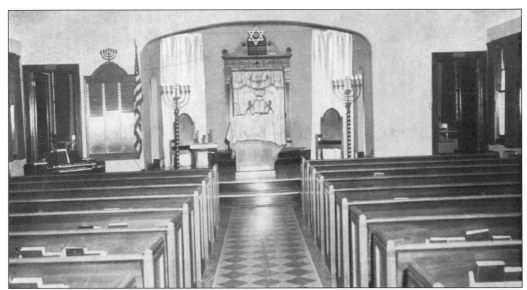

A 1950 view of the sanctuary interior of Temple Beth El shows how the synagogue looked before the addition of the wood paneling around the ark. (Courtesy of Jeff Miller.)

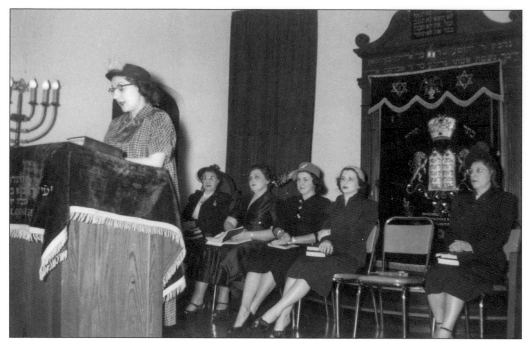

Shown here is a sisterhood worship service at Temple Beth El in Beckley during the early 1940s. Sisterhood was the women's auxiliary organization in reform synagogues across the United States. The Beckley Sisterhood was actually organized in 1925 just a few years prior to the formation of Temple Beth El in Beckley. Sisterhoods often organized and led special religious services for the congregation, such as the one shown in this early photograph. (Courtesy of Jeff Miller.)

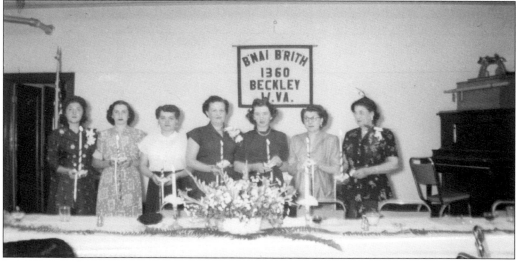

In most Jewish communities, there were often several Jewish organizations in addition to the temple or synagogue. Most smaller communities also had chapters of Hadassah and B'nai B'rith. The events, membership, and fund-raising often overlapped those of the local temple, but they provided additional ways for Jews to participate in Jewish life on a local and national level. In this 1940s photograph are some of the wives of members of local B'nai B'rith Lodge 1360 participating at a lodge event at Temple Beth El. B'nai B'rith Beckley Lodge 1360 was established in 1939. (Courtesy of Jeff Miller.)

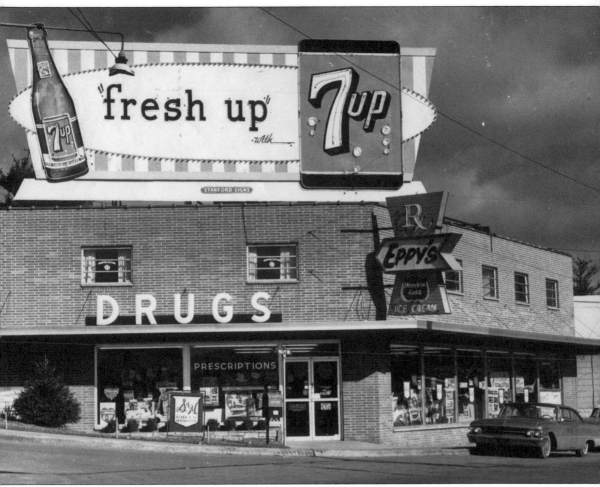

Eppy's Drugs in Beckley was located at Valley Drive and North Oakwood Avenue for many years. It was owned and operated by Milton and Lucille Epstein. The business is still in operation in Beckley, though not by the original family. (Courtesy of West Virginia and Regional History Collection, West Virginia University Libraries.)

The first synagogue of Ahavath Sholom Congregation was the former Scott Street Presbyterian Church in Bluefield. The building was purchased by the congregation in 1907 and remodeled for use as a Jewish house of worship. The former church building served as a synagogue until 1941. The congregation's new synagogue on Albemarle Street was completed in 1948 and dedicated in 1949. (Courtesy of Ahavath Sholom Congregation.)

The current synagogue building of Ahavath Sholom in Bluefield has been maintained beautifully by the congregation. The style of the structure combines classic Mid-Century Modern architecture along with some traditional detailing. (Author's collection.)

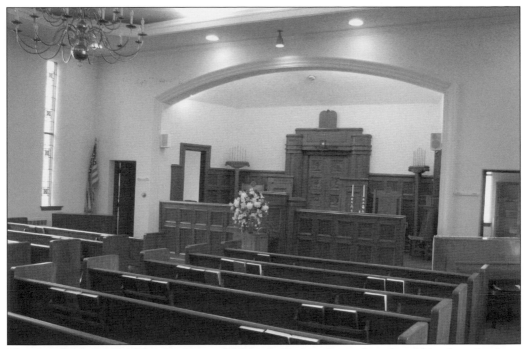

This present-day view of the sanctuary of Ahavath Sholom shows the ark and bimah at the front of the sanctuary. The sanctuary appears much as it did when the building was dedicated years ago. (Author's collection.)

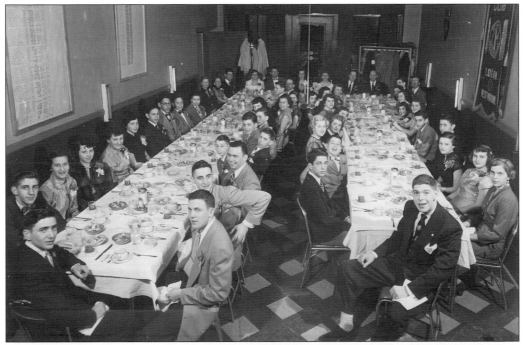

Ahavath Sholom's temple youth group holds a special dinner in Bluefield in the 1940s. The youth group was formed in 1947 and was a member of the National Federation of Temple Youth Groups. (Courtesy of Ahavath Sholom Congregation.)

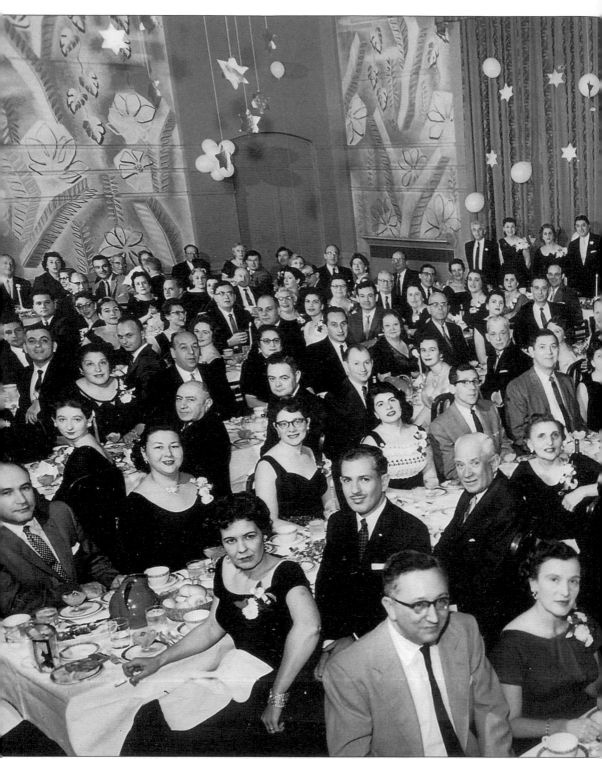

Congregation Ahavath Sholom celebrated its 50th anniversary in 1957 and held a formal dinner at the West Virginian Hotel in Bluefield to commemorate the special event.

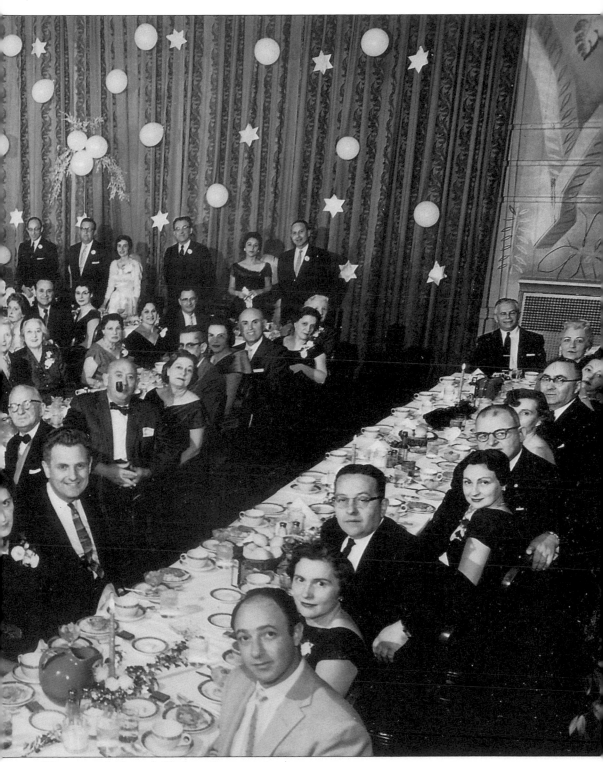

(Courtesy of Ahavath Sholom Congregation.)

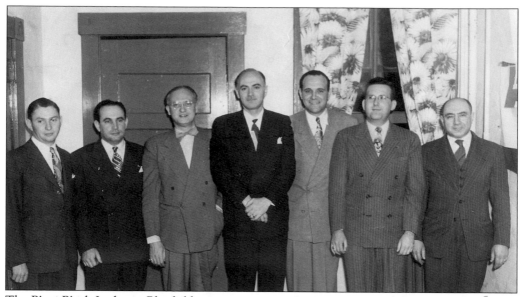

The B'nai B'rith Lodge in Bluefield was an active men's organization and this 1940s photograph shows some of the members at a meeting. Shown from left to right are Dr. Jay Rodgin, Leroy Katz, a national B'nai B'rith representative (name unknown), Al Rosenfeld, Sidney Rosenthal, Meyer Spiro, and Sam Slifkin. The Bluefield-Princeton B'nai B'rith Lodge 967 was first established around 1907 and was reorganized and rechartered in 1923. (Courtesy of Doris Sue and Norris Kantor.)

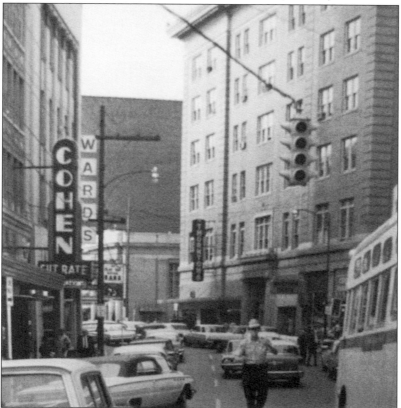

This 1960s street scene in downtown Bluefield shows Cohen's Cut Rate Drugs and other businesses. Cohen's was a statewide chain of 40 stores owned and operated by brothers Saul, Marvyn, and Louis Cohen. All were pharmacists and the sons of a Charleston grocer. The chain of stores, which was begun in the late 1920s, was sold to Revco in 1971. (Courtesy of the Eastern Regional Coal Archives.)

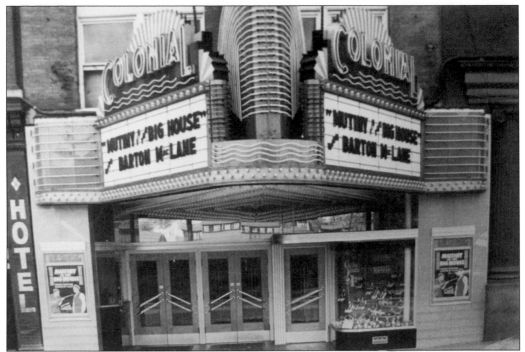

The Colonial Theater downtown on Princeton Avenue was a Bluefield landmark for decades. Built by Samuel Matz in 1916, it was located adjacent to the Matz Hotel, which was built in 1911. Son Max Matz later became president of the hotel and theater. Both buildings were torn down in late 2009 after the Matz Hotel partially collapsed. (Courtesy of the Eastern Regional Coal Archives.)

Kammer Furniture store, located downtown on Bland Street, has been a Bluefield retail institution for decades. It was established in 1932 by Harry Kammer and is now run by his grandson Harry Kammer. This 1948 photograph shows Harry Kammer and son Max in the appliance department of the store. (Courtesy of the Kammer family.)

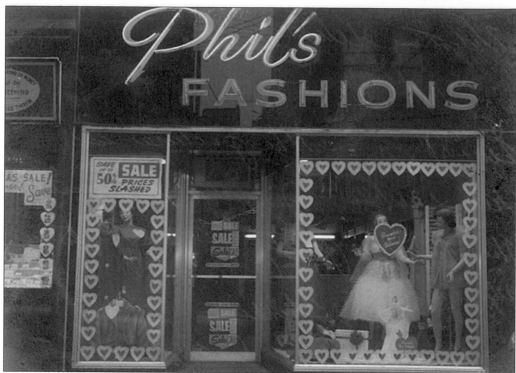

Phil's Fashions was a women's ready-to-wear clothing store located on Federal Street in downtown Bluefield. It was established in 1956 by Phil Shapiro, who was a traveling salesman from New York City. Shapiro ran this successful business until 1988 when he died suddenly of a heart attack. The original store exterior is shown above decorated for a Valentines Day sale in 1959. The Mercer Mall location is shown below. (Both courtesy of Sharon Shapiro.)

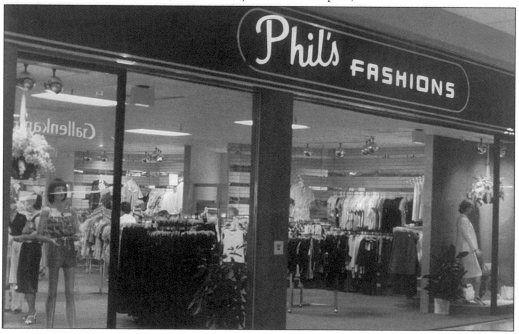

Phil Shapiro and daughter Sharon are seated in the back of Phil's Fashions in downtown Bluefield in 1970. The Mercer Mall location of Phil's Fashions was the last location of this local business. The store, opened in 1981, was one of the few locally owned stores to successfully make the move from downtown Bluefield to the suburban mall. At age 20, Sharon Shapiro inherited the business after her father's sudden death and ran it for a year before closing. (Courtesy of Sharon Shapiro.)

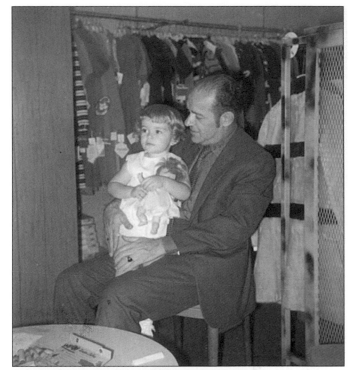

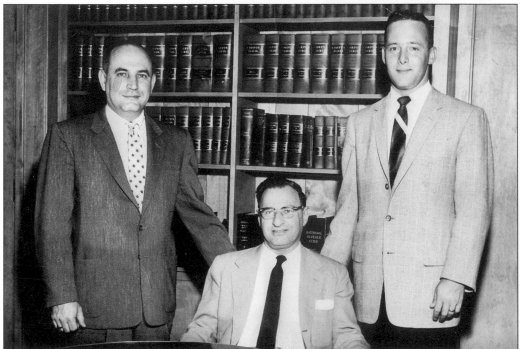

The law firm of Katz, Katz, and Kantor was established in 1931 by Jerome Katz, who came to Bluefield from Baltimore in 1917 as a young child with his family. Pictured in the library of Bluefield's Ritz Building in 1958 are Jerome Katz (left), Leroy Katz (center), and Norris Kantor. (Courtesy of Doris Katz Kantor.)

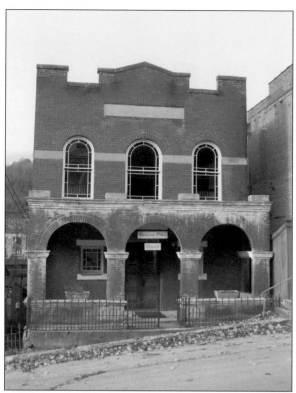

Pocahontas was a small coal-mining town located across the state line from Bluefield, Virginia. It was home to an early small Jewish community made up primarily of merchants. Jewish settlement shifted in the first few decades of the 20th century from Pocahontas to nearby Bluefield, resulting in the establishment of the Bluefield synagogue. The Pocahontas synagogue, which was built in 1912, was used for a relatively short period of time. It now serves as a Christian church, and the present owners are hoping to renovate and restore this small-town landmark. (Author's collection.)

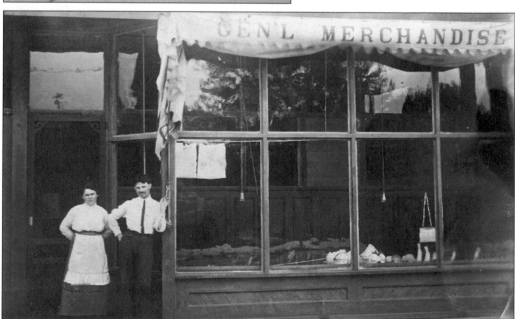

Dora and Harry Barbakow stand in front of Barbakow's General Merchandise, located on Mercer Street in Princeton, in this 1909 view—the same year it was established by Harry Barbakow. The Barbakows were among the first Jewish residents of Princeton. Harry Barbakow was a learned man and led orthodox religious services for the Jews of Princeton for many years. (Courtesy of Bonnie Barbakow Greenberg.)

Barbakow's soon became a successful business and expanded its facilities. The general merchandise store, shown here in the 1920s, evolved into a ladies' ready-to-wear business whose slogan was "Barbakow's for Finer Feminine Fashions." The business had a Princeton presence for 72 years and was one of the oldest Jewish businesses in town. (Courtesy of Bonnie Barbakow Greenberg.)

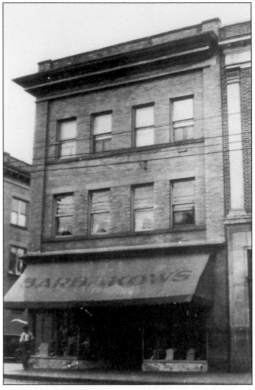

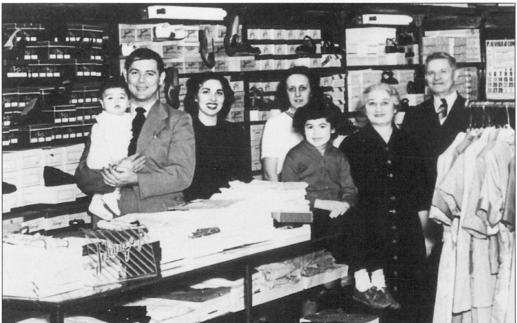

The Barbakow family is gathered inside their store in downtown Princeton around 1949. Shown from left to right are Yankee Barbakow (holding son Dennis), wife Libby Barbakow, saleslady Mary Raines, daughter Bonnie Barbakow, and grandparents Lily and Harry Barbakow. (Courtesy of Bonnie Barbakow Greenberg.)

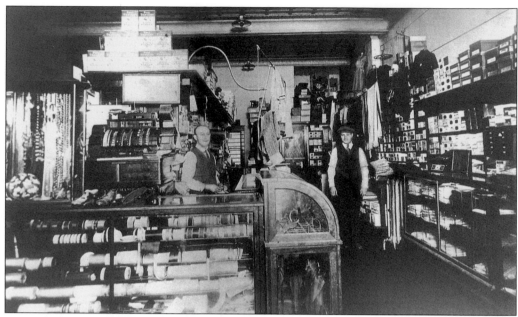

Deitz Brothers General Store was located at 1603 North Walker Street in Princeton. This 1920s view of the store shows brothers Henry (in hat) and Jake Deitz (behind the counter). The store was established by brothers Henry, Harry, and Jake Deitz shortly after coming to Princeton from Russia in 1913. The North Walker store was opened in 1918 and was in operation until 1993. (Courtesy of Calvin and Sandy Deitz.)

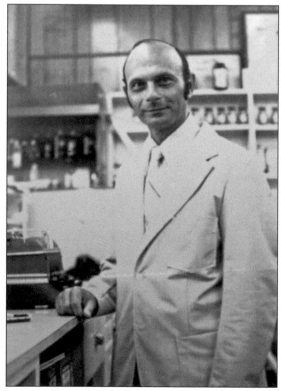

Pharmacist Calvin Deitz is shown working at his People's Pharmacy in Princeton in the late 1960s or early 1970s. The store was located at 929 Mercer Street and operated from 1953 to 1973. (Courtesy of Calvin and Sandy Deitz.)

Princeton's East End Department Store on Mercer Street was owned and operated by the Lisagore family from the early 1900s to 1930. (Courtesy of Calvin and Sandy Deitz.)

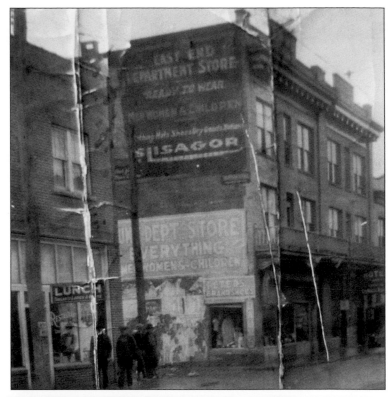

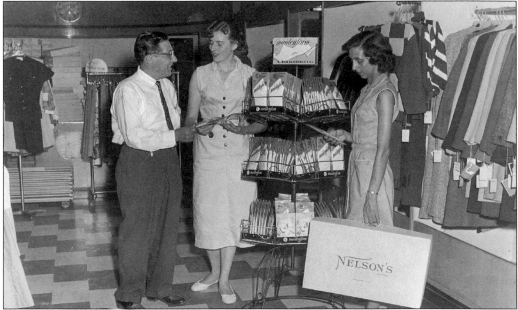

Nelson's Dress Shop, located on Mercer Street in Princeton, was established in the 1930s by Frank Nelson. The family business was sold in 1975 to Jim Storts, who ran it for about 10 years. Frank Nelson was originally from Portsmouth, Virginia, and was married to Beatrice Effron of Bluefield. This 1956 photograph shows Frank Nelson with a salesgirl and customer. (Courtesy of Stanley Nelson.)

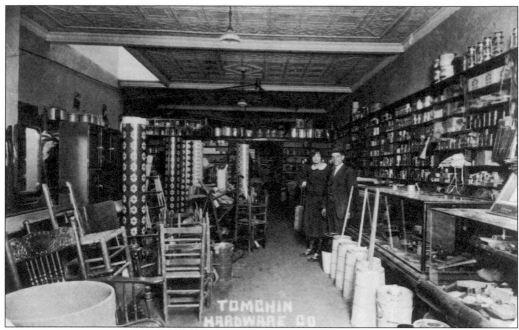

Joe Tomchin and his sister Ida work inside their Tomchin's Hardware Store in Princeton around 1923. Joe Tomchin came to the United States from Minsk, Russia, and later brought many of his family members over, including sister Ida. He later established the Tomchin Furniture Company, which was in business until 2009 when the last store closed. (Courtesy of Abe and Sue Tomchin.)

Joe Tomchin (left) and his two sons, Harold (center) and Abe ("Buddy"), are pictured in front of Tomchin Furniture's main store on Mercer Street in downtown Princeton in 1938. Tomchin's later opened branch stores in Northfork and Mullens They also owned and operated Best Furniture in Welch. The Tomchin Planetarium and Observatory at West Virginia University is named in honor of the late Harold Tomchin. (Courtesy of Abe and Sue Tomchin.)

Bonnie Barbakow of Princeton represented West Virginia in the 1961 America's Junior Miss contest held in Mobile, Alabama. (Courtesy of Bonnie Barbakow Greenberg.)

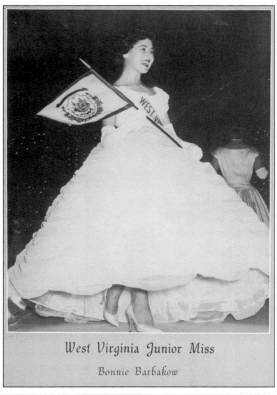

West Virginia Junior Miss

Bonnie Barbakow

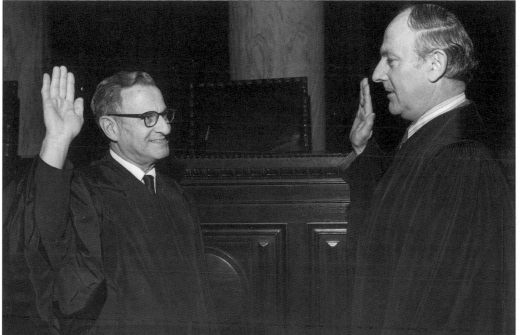

West Virginia Supreme Court Justice Kaplan swears in Bluefield attorney Jerome Katz as judge of the Mercer County Circuit Court around 1971 in Princeton, the county seat. (Courtesy of Doris Katz Kantor.)

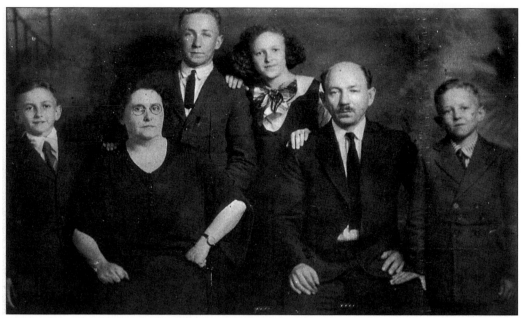

The Lisagore family was a well-known Jewish family in Princeton. A family photograph from 1918 shows, from left to right, (first row) Sam, Sarah, Benjamin, and Maurice; (second row) Irving and Josephine. (Courtesy of Calvin and Sandy Deitz.)

Shaman's was a clothing store that specialized in fine men's clothing and catered to college-age men. Established and operated by Samuel Shaman, the store was open as early as 1930 and closed in the early 1950s. Pictured here is a high school yearbook advertisement from the 1950s. (Author's collection.)

Two

CHARLESTON

Charleston has the largest Jewish community today in West Virginia. The first permanent Jewish settler in the city was Meyer Hirsch May around 1854. The first Jewish religious services were held in 1871, and by 1873 the Hebrew Educational Society (B'nai Israel Congregation) was formed by 12 men, primarily German-speaking Jews, including Meyer Hirsch May, S. M. Loewenstein, Moses and Philip Frankenberger, and David Hess. Other founding families included Baer, Freundlich, Jelenko, Moses, Peyser, and Schwabe. The Germania Club, a Ladies Auxiliary, and the Phoenix Club were other early Jewish groups.

The congregation was reform from the start and was one of the first members of what is today the Union for Reform Judaism. The Virginia Street Temple was dedicated in 1894 and was an imposing temple of Byzantine-Moorish design. B'nai Israel remained there until 1960, when the new Kanawha Boulevard temple was dedicated.

Jewish immigration to America increased between 1890 and 1914, and more Jews from Eastern Europe arrived here. They also came to Charleston and brought with them orthodox Jewish practices. An orthodox congregation, B'nai Jacob, was organized in 1894 by Wolfe Bekenstein, Abraham and Fishel Boiarsky, Israel and Sol Cohen, Louis Frank, Abraham Frankel, Jacob Gluck, Solomon Hark, Ben Melman, Julius Nearman, Isaac Padlibsky, Isaac Pimpstein, Jacob Polen, Louis Ruffner, A. P. Silverstein, and Max Slotnick.

B'nai Jacob met in rented spaces and then purchased the former State Street temple of the reform congregation. In 1908, the former State Street Methodist Church was purchased. In 1950, B'nai Jacob dedicated its first purpose-built synagogue on Virginia Street near the state capitol. Today, it is the only traditional Jewish congregation in the state and is the largest in terms of membership.

The Jews of Charleston were engaged primarily in retail professions. Some of the earliest Jewish stores were established by Moses Frankenberger, Albert May, and Solomon Loewenstein. These men and others gained early prominence in Charleston. For decades many stores in downtown Charleston were Jewish owned and operated. Jews were also engaged in a variety of professional careers. Berman's, Frankenberger's, Galperin's, Levin Brothers, Ostrin's, Mendelsohn's, Sheff's, Solof's, and others were well-known businesses in town. Today most of Charleston's Jewish residents are in the professions, though there are still some family-owned businesses such as Goldfarb's and Ostrin's.

The Charleston Jewish community today is stable and active, with two large Jewish congregations and a full host of Jewish charitable and social organizations. The Jewish community is known for civic pride, philanthropy, and involvement in all aspects of life in the state.

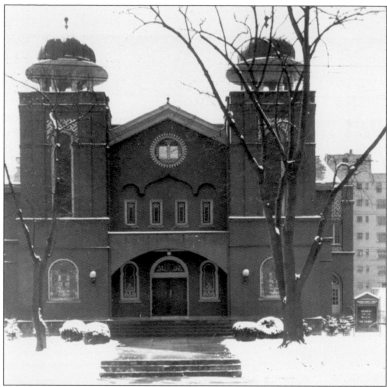

The Virginia Street Temple of Congregation B'nai Israel is shown here in the early 1950s. The venerable Moorish Revival building was dedicated in 1894 and for years was a landmark in the city. (Courtesy of Temple Israel and Philip Angel Jr.)

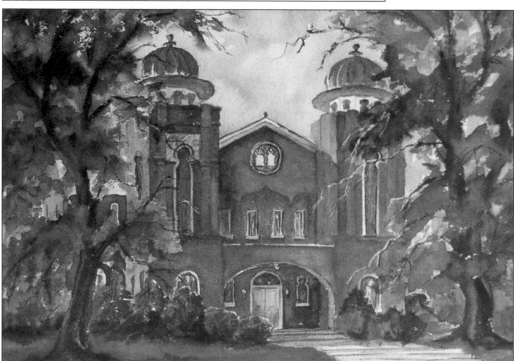

A large watercolor painting of the Virginia Street Temple now hangs in the lobby of the present temple building on Kanawha Boulevard in Charleston. (Author's collection.)

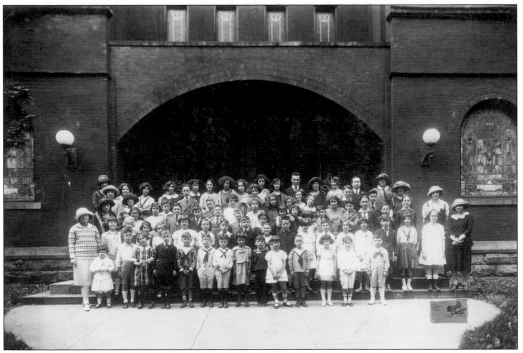

The religious school of the Virginia Street Temple is gathered at the entrance to the temple in a 1920s photograph. (Courtesy of Temple Israel and Philip Angel Jr.)

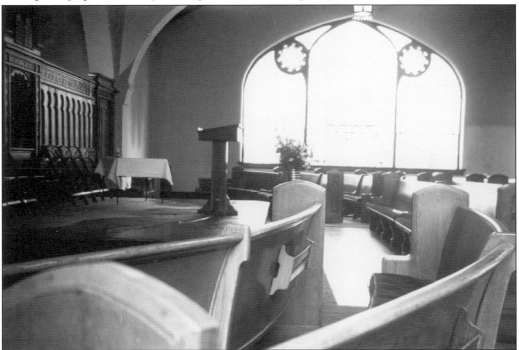

Seen here is an interior view of a portion of the sanctuary at the Virginia Street Temple. It was taken at the time of the move to the new temple on Kanawha Boulevard. (Courtesy of Temple Israel and Philip Angel Jr.)

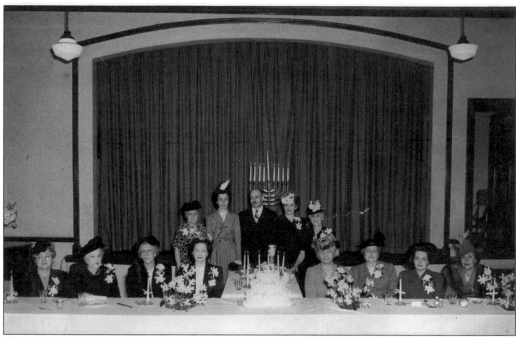

The sisterhood of the Virginia Street Temple holds a celebratory event in the social hall sometime in the 1930s. (Courtesy of Temple Israel and Philip Angel Jr.)

This view of the new Temple Israel on Kanawha Boulevard was taken shortly after the building was completed in 1960, and prior to the installation of the large sculpture on the front exterior. (Courtesy of Temple Israel and Philip Angel Jr.)

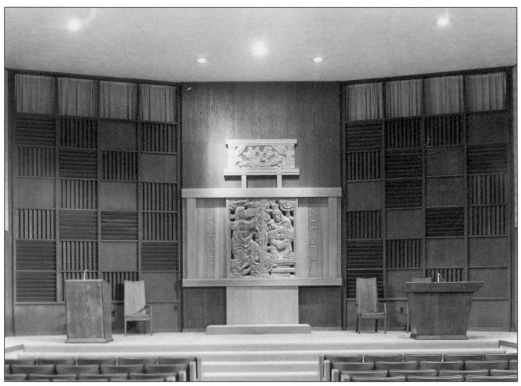

Temple Israel had just moved into their new Kanawha Boulevard temple when this photograph of the ark and sanctuary interior was taken. (Courtesy of Temple Israel and Philip Angel Jr.)

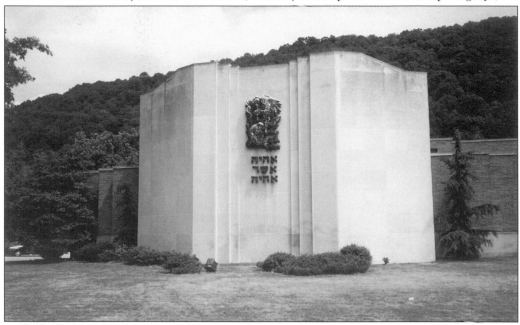

A 1990 view shows the exterior of Temple Israel, with a large decorative sculpture by Milton Horn on the front of the sanctuary portion of the temple. The work of Milton Horn can be found on a number of Mid-Century Modern American synagogues. (Author's collection.)

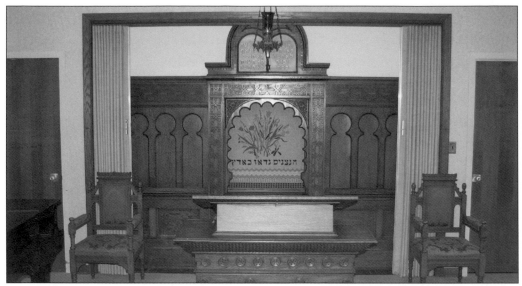

The present-day small chapel at Temple Israel features many items from the historical Virginia Street Temple, including the ark, eternal lamp, lectern, bimah chairs, and a round stained glass window. (Author's collection.)

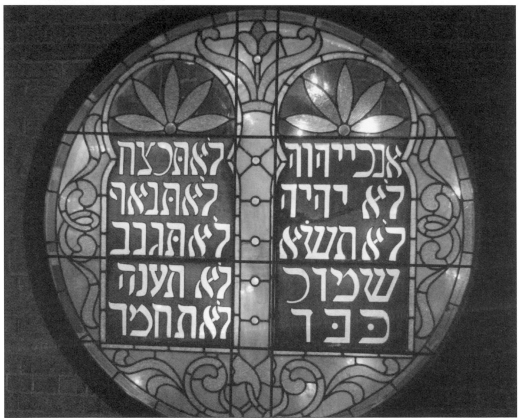

A beautiful round stained glass window from the Virginia Street Temple is part of the interior decoration in the lobby of Temple Israel. (Author's collection.)

This house on Libby Street in Charleston, pictured in 1890, was the home of Julius Nearman. It was the first meeting place of the second Jewish congregation in Charleston, B'nai Jacob Synagogue. (Courtesy of Marcia Jo Zerivitz.)

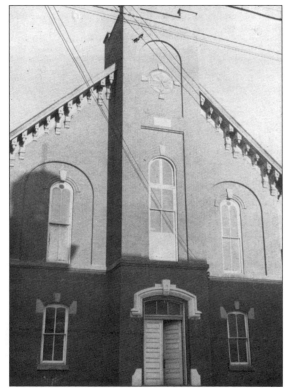

This was the third location of the B'nai Jacob Synagogue, from 1908 to 1948, at Lee and Court Streets in central Charleston. The building was the former State Street Methodist Church. It was in use until the congregation built their present synagogue on Virginia Street East in 1949–1950. (Courtesy of Marcia Jo Zerivitz.)

The officers and board of the B'nai Jacob's Chevra Kadisha (burial society) gather for a photograph in 1950. The burial society was a respected and important organization and an integral part of orthodox or traditional Jewish congregations and communities. (Courtesy of Marcia Jo Zerivitz.)

The cornerstone laying ceremony on October 10, 1948, for the new synagogue of B'nai Jacob was a proud moment in the history of the congregation. Their new building was dedicated the following year. (Courtesy of Marcia Jo Zerivitz.)

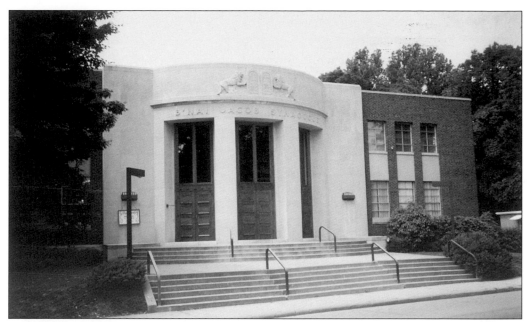

The well recognized synagogue of B'nai Jacob was completed in 1949–1950 and contains a large sanctuary, chapel, religious school, social hall, and gymnasium. Contemporary stained glass windows were installed on the front entrance of the synagogue a few years after this photograph was taken in 1990. The sanctuary was extensively renovated and remodeled during the summer of 2007. (Author's collection.)

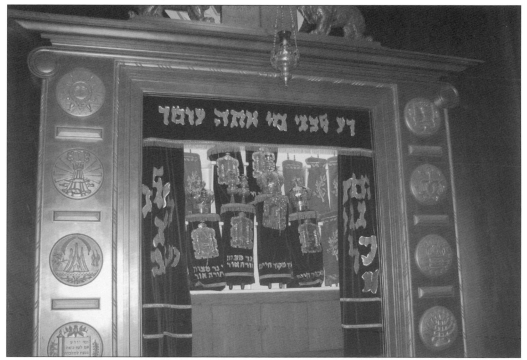

The congregation's Torahs are seen in this present-day close-up view of the elaborate ark at B'nai Jacob. (Author's collection.)

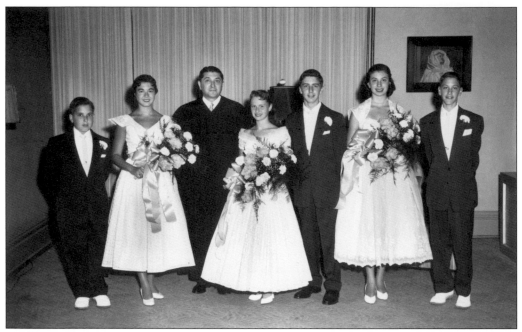

The 1955 Confirmation class gathers at the Virginia Street temple in Charleston. From left to right are Kenneth Kleeman, Marcia Jo Koenigsberg (Zerivitz), Rabbi Volkman, Penny Bedwinek (Dorfman), Richard Preisman, Jackie Toovy (Artz), and Richard Hark. The reform congregation remained in the Virginia Street Temple from 1894 to 1960. (Courtesy of Marcia Jo Zerivitz.)

A Mothers' Day program was held in 1946 at B'nai Jacob Congregation in Charleston. This was in the basement activities room of the old synagogue at Court and Lee Streets. The orthodox congregation stayed here until 1950, when they made the move to their current synagogue. (Courtesy of Marcia Jo Zerivitz.)

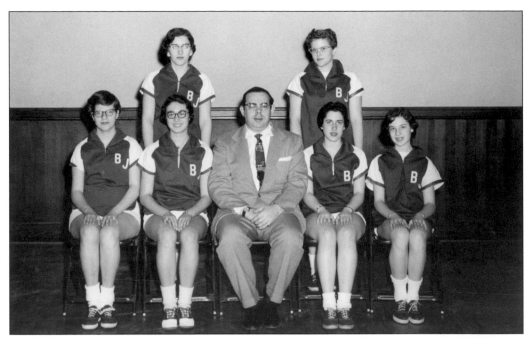

The girls' basketball team at B'nai Jacob Congregation in Charleston is seen in this 1955 group photograph. From left to right are (first row) Debby Levinson, Marcia Jo Koenigsberg (Zerivitz), coach (and cantor) Paul Reiss, Harriet Weiner (Samuels), and "Little" Harriet Weiner; (second row) Deena Grablow (Gill) and Marilyn Kravetz. (Courtesy of Marcia Jo Zerivitz.)

Special sales are offered in this 1932 advertisement for Dan Cohen Shoes on Capitol Street in Charleston. The company had several West Virginia branches, including Wheeling. There were also branches throughout the Southeast, including Atlanta, Little Rock, Louisville, Knoxville, and Birmingham. (Courtesy of Jerry Waters.)

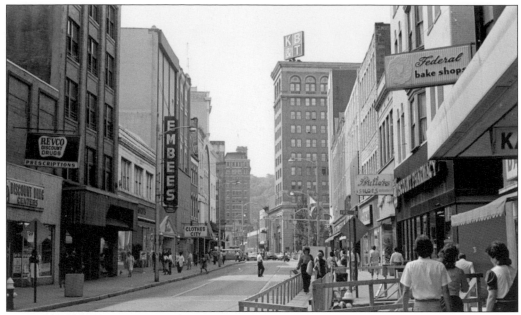

A 1970s view of Capitol Street includes Embee's clothing store, seen on the left. Farther down the street are Galperin Music Company and Cohen's Drugs. At one time Embee's had seven stores throughout West Virginia. The chain went "discount" in 1985 to try to compete with other stores, but ceased operations in 1986. The last store to close was the Charleston Town Center shopping mall location. (Courtesy of Jerry Waters.)

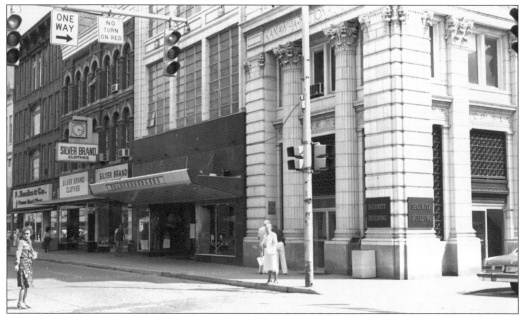

Capitol Street in the 1970s shows popular Frankenberger's Department Store and Silver Brand Clothes. Moses Frankenberger was a tailor from Bavaria who came to the United States in 1851. He established a clothing store in Charleston around 1880 or earlier. Frankenberger's grew to become one of the most popular stores in town. Frankenberger was also one of the founders of the Citizens Bank in Charleston. (Courtesy of Jerry Waters.)

The former Frankenberger location on Capitol Street in Charleston was renovated and now contains offices and other businesses. (Author's collection.)

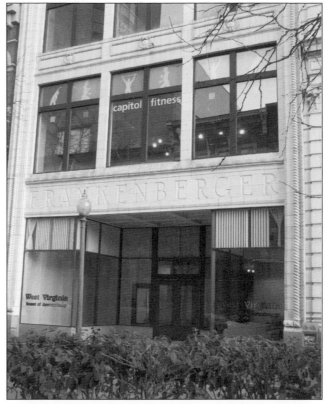

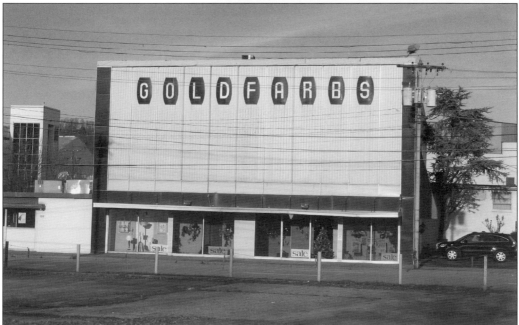

Goldfarb's, shown here in a present-day view, is a lighting and electrical supply company established in 1933. It is located on Virginia Street downtown and is in its third generation of family ownership. (Author's collection.)

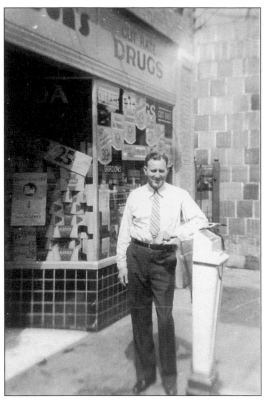

David Leonard Gordon stands outside his store, Gordon's Cut Rate Drugs, on East Washington Street in Charleston in the 1940s. The store was in operation until the late 1950s. (Courtesy of Marsha Gordon Platnick.)

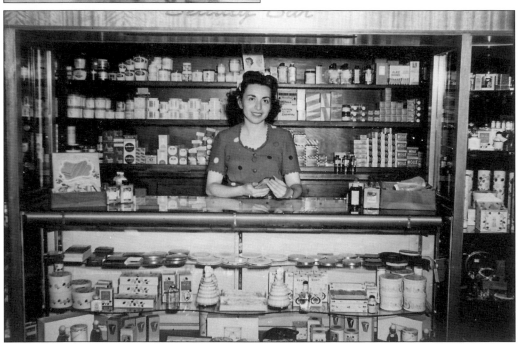

Esther Shapiro Gordon worked along with her husband at the family store, Gordon's Cut Rate Drugs, in Charleston. She is shown here behind the cosmetics counter in the late 1940s. (Courtesy of Marsha Gordon Platnick.)

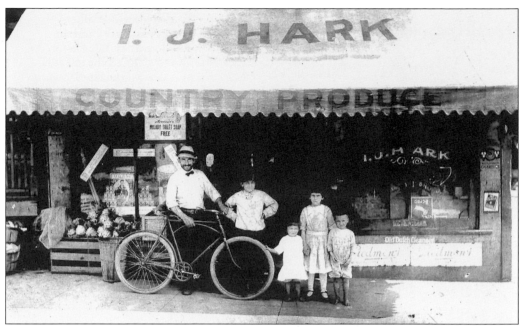

This 1913 view shows the exterior of the I. J. Hark Country Produce market in Charleston. Shown from left to right are I. J., Zundel, Esther, Ida Rose, and Israel Hark. (Courtesy of Dr. William Hark.)

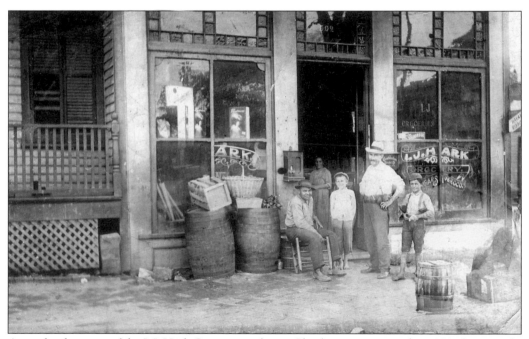

An earlier location of the I. J. Hark Grocery market in Charleston is seen in this 1909 photograph. Shown from left to right are Charles Mills, J. Lewis Hark, I. J. Hark, and Edwin Haddad. (Courtesy of Dr. William Hark.)

Headquarters for the Working Man and His Family . . .

LEVIN BROS. DEPT. STORE, INC.
LEVIN'S

On the Boulevard at Alderson
in Downtown Charleston
For 33 Years . . .

The Levin Brothers Department Store in downtown Charleston was established around 1917 as an affordable shopping option in town. A 1950 advertisement appeared in the dedication booklet for the new B'nai Jacob Synagogue. (Author's collection.)

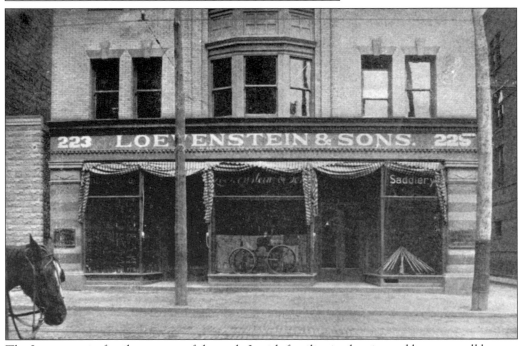

The Loewenstein family was one of the early Jewish families in the city and became well known in business and civic circles. Their Capitol Street hardware store, shown in 1907, is now a local landmark. (Courtesy of Jerry Waters.)

The Loewnsteins' former store has been restored to appear as it did when it first opened. It now contains offices and retail stores. (Author's collection.)

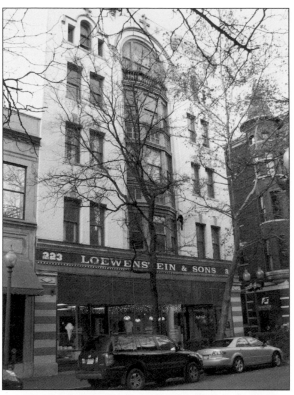

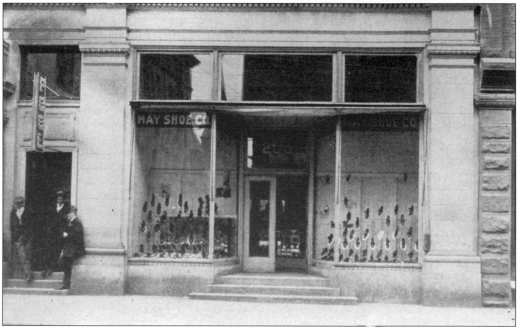

The May Shoe Company, shown here in 1907, was an early Jewish business in Charleston. The store soon evolved into the Schwabe-May clothing store, established by cousins Albert Schwabe and Isadore May. The business was always family-run and moved several times over the years before closing in 2007. (Courtesy of Jerry Waters.)

PREVIEW
FOR SPRING

Two Hats Chuck Full of Style

"THE WALKER"
Dobbs
With the English curl
to the back and snap
in front

Four Colors
Nacre—Gray of Richness
Garvin—Tobacco Brown
Nut—Sunny Tan
Pearl—Plain Gray

Priced at

$8

"THE NONESUCH"
Dobbs
A distinctly styled hat
with the famous
Cavanaugh Edge

Four Colors
Zinc—Pure Silver
Mastic—Rich Tan
Pecan—Neutral Brown
Pearl—Plain Gray

Priced at

$10

SCHWABE & MAY
"ON QUARRIER"

The Schwabe and May store was located on Quarrier Street in downtown Charleston in 1931, as shown in this advertisement. (Author's collection.)

The suburban Charleston location of the Pied Piper store is the current location of this nationally known music store. The Huntington company was established in 1967 by Lawrence E. Levine and his brother Charles S. Levine. It is one of the largest music stores in the country. The main location in downtown Huntington closed in 2002, leaving the suburban Charleston location as the main location of the business. (Courtesy of L. Kevin Levine.)

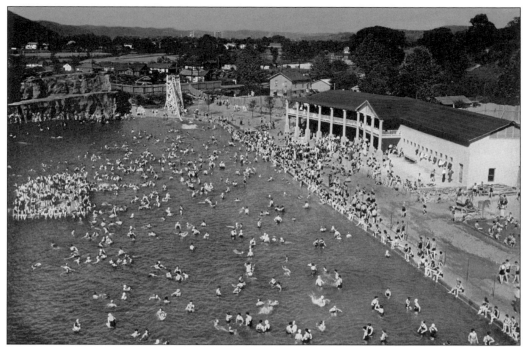

The Rock Lake Pool, shown in this 1949 photograph, was one of the most popular recreational venues in Charleston. Located in South Charleston at the site of an old quarry, the pool was opened by Joe, David, and Sam Wilan, and operated from 1942 to 1985. (Courtesy of Jerry Waters.)

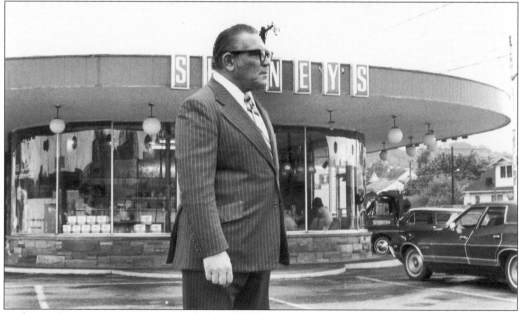

In this early-1970s view, Alex Shoenbaum stands outside the first location of Shoney's Restaurant on Kanawha Boulevard in Charleston. Begun in 1947 as the Parkette, the drive-in restaurant was renamed Shoney's in 1952 and grew into a popular chain. The original location closed in 1975. The Schoenbaums became a well-known family in Charleston, whose members were known for being generous philanthropists. (Courtesy of Betty Schoenbaum.)

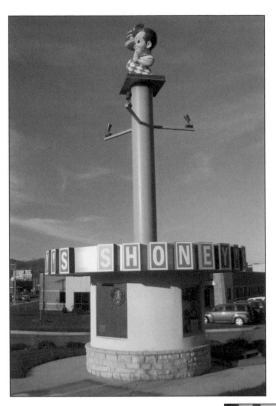

The Schoenbaum family recently built a small museum and memorial on the site of the original Parkette and Shoney's location in Charleston. Shoney's was one of the most famous institutions in Charleston. There is an informational plaque, and the sides of the memorial have showcases filled with restaurant memorabilia. (Author's collection.)

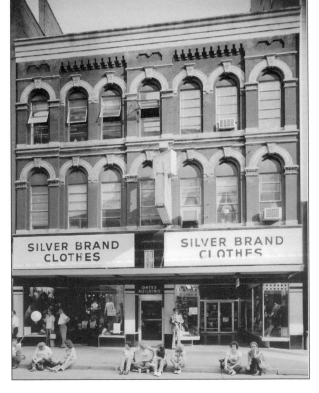

This early-1970s photograph shows the front of the Silver Brand Clothes store on Capitol Street in downtown Charleston. The Sherman family began the business before 1935. The company, which also had locations in Beckley and Logan, was still in operation in 1986. (Courtesy of Jerry Waters.)

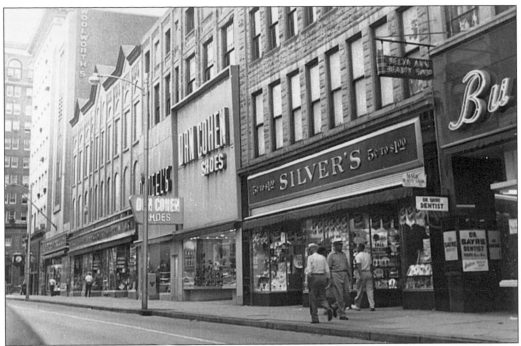

Dan Cohen Shoes, Silver's Variety Store, and Mangel's are shown in this 1950s view of Capitol Street in downtown Charleston. (Courtesy of Jerry Waters.)

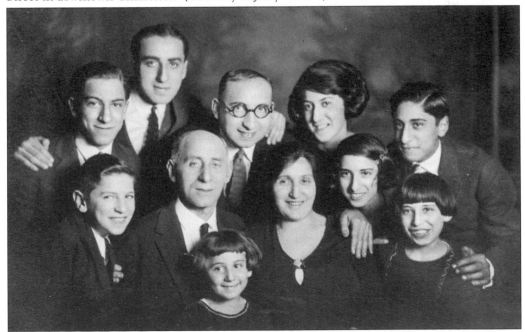

The Angel family of Huntington is shown in this 1920s photograph. Pictured from left to right are (first row) Anne; (second row) Harry, Henry, Charlotte, Ces, and Fanny; (third row) Philip, Max, Maurice, Etta, and Abe. Philip Angel married Frances Levy and they became leading citizens of Charleston. Frances Levy Angel was an early champion of women's rights and was involved in a variety of social causes. (Courtesy of Philip Angel Jr.)

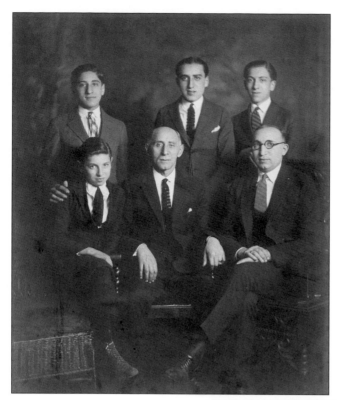

Henry Angel and his sons pose for this 1920s family photograph. From left to right, they are (first row) Harry, Henry, and Maurice; (second row) Abe, Max, and Philip. (Courtesy of Philip Angel Jr.)

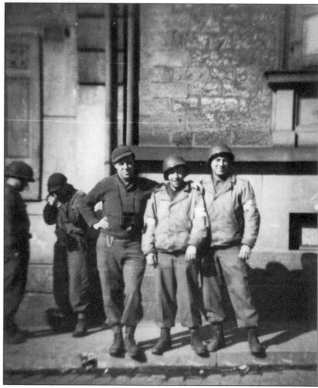

Leonard Gordon (center) of Charleston served during World War II. He is pictured with an army buddy and a local friend in occupied Germany at the end of war. (Courtesy of Marsha Gordon Platnick.)

Marcia Jo Koenigsberg (Zerivitz), pictured in this 1957 photograph, was assistant head cheerleader and the first Jewish girl known to become a cheerleader at Charleston High School. (Courtesy of Marcia Jo Zerivitz.)

Simon Meyer was a successful homebuilder in Charleston, and both he and his wife, Ida, were active members at B'nai Jacob Synagogue. Their daughter, Joan, married Art Weisberg of the well-known Huntington firm, State Electric Supply. Upon the death of Simon Meyer, financial resources were made available from the estate so that a "West Virginia Jewish Reunion" could be held periodically to help sustain his vision of a strong and vibrant Jewish community. The reunion is a cultural, religious, and historically oriented event attended by both current residents and those Jewish families no longer residing in West Virginia. (Courtesy of Joan Weisberg.)

This 1926 photograph shows the men of Charleston's Polan family. From left to right are Lake Polan with his sons Albert, Edward, Mickey, Charles, and Lake Jr. The Polan family operated Polan's, a women's clothing store, in Charleston for many years. (Courtesy of Marilyn Polan.)

This 1946 photograph shows the women of the Polan family. From left to right are Francis Puckett Polan, Ruth Polan, Dorothy Lewis Polan, Josephine Polan Smith, Nancy Moore Polan, and infant Mary Lake Polan. (Courtesy of Marilyn Polan.)

Three

HUNTINGTON

Samuel and Dora Gideon moved to Huntington from Cincinnati in 1872 and were the first recorded members of the Jewish faith to live in the town. As other Jews moved to Huntington, they formed a religious/social organization called the Almonia Club. In 1887 a group of 20 Jewish families organized the Ohev Sholom temple, which received a charter from the state in 1889. Charter members included Samuel Gideon, Emanuel Biern, Mike and Julius Broh, Leon Aturberger, L. Kolner, and J. Siegler. By 1891, the temple had adopted the reform ritual and had also begun construction on their first temple at Fifth Avenue and Tenth Street. By 1917, there were over 300 Jews living in Huntington. Because of this growth, it was decided that a larger temple would be needed. A site was purchased in 1919 at Tenth Avenue and Tenth Street, and the beautiful new domed temple was dedicated in 1925.

In 1910, a group of Jewish families in Huntington that preferred the orthodox form of worship organized the B'nai Israel Congregation. The founding members were Henry Angel, Emanuel Biern, Harry Brownstein, Joseph Cohen, Maurice Fetter, Samuel Glick, Samuel Gore, S. K. Hartz, Jake Hermanson, Harry Mazo, Max Pulverman, Harry Rose, and Albert Schlossberg. B'nai Israel worshiped in a variety of spaces, and in 1924, a beautiful new synagogue was dedicated at Ninth Avenue and Ninth Street. B'nai Israel was originally orthodox but gradually became more conservative in its worship theology. Dual membership between the congregations occurred in some instances and also occurred in many of the local Jewish organizations, such as the B'nai B'rith Lodge 795, Hadassah, and the Federated Jewish Charities of Huntington.

Jews in Huntington were prominent in the retail sector, and many Jews operated furniture and electrical supply businesses as well as a variety of other commercial enterprises. State Electric Supply, West Virginia Electrical Supply, and Glaser Furniture are among the remaining Jewish-owned and operated companies in Huntington today.

Both congregations experienced steady declines in membership during the late 1960s and early 1970s. Financial difficulties ensued, and merger talks began between Ohev Sholom and B'nai Israel. The merger officially took place in 1974 with both buildings being used. This continued until 1978 when the B'nai Israel synagogue was sold and the Torahs, stained glass windows and other artifacts were transferred to the Ohev Sholom temple, known as B'nai Sholom Congregation since the 1974 merger. In 2003, the newly restored synagogue of B'nai Sholom was rededicated. The members of the congregation today remain committed to the spiritual and financial health of B'nai Sholom despite declines in membership.

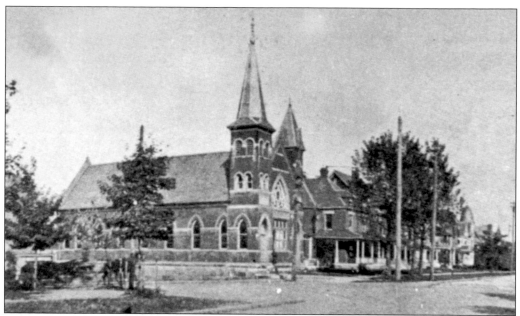

Ohev Sholom Congregation of Huntington was officially organized in 1887 and their first temple, shown here in an early photograph, was dedicated in 1892. (Courtesy of B'nai Sholom Congregation.)

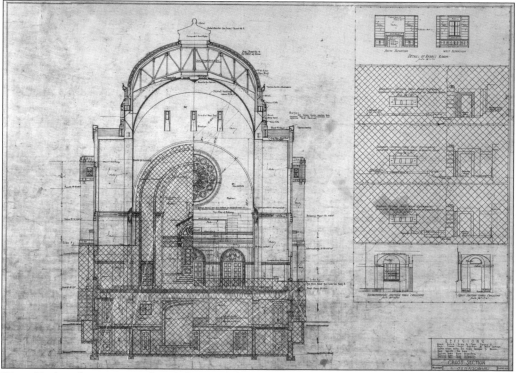

B'nai Sholom has preserved and digitized the blueprints for the design of their original Ohev Sholom temple in Huntingon. The temple is a landmark Jewish structure in the state. (Courtesy of B'nai Sholom Congregation.)

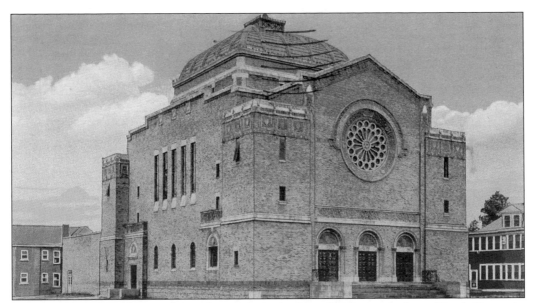

A late-1920s postcard view shows the newly built Ohev Sholom temple on Tenth Street in Huntington. The temple is the largest synagogue structure in the state and is listed on the National Register of Historic Places. It was designed by the noted West Virginia firm of Meanor and Handloser and dedicated in 1926. (Author's collection.)

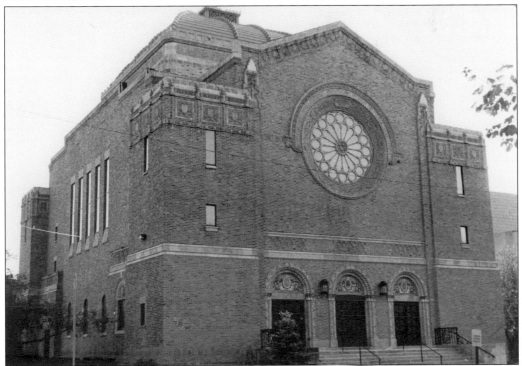

The facade of B'nai Sholom's temple is pictured as it appeared in the early 1990s prior to the extensive restoration that took place in 2003. The temple was built for the Ohev Sholom reform congregation and when Huntington's conservative synagogue, B'nai Israel merged with them, the new united congregation took the name B'nai Sholom. (Courtesy of B'nai Sholom Congregation.)

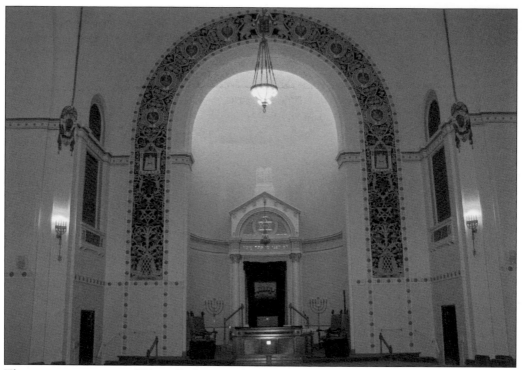

The ornate sanctuary of B'nai Sholom is a beautiful worship space and contains detailed and colorful decorations. (Author's collection.)

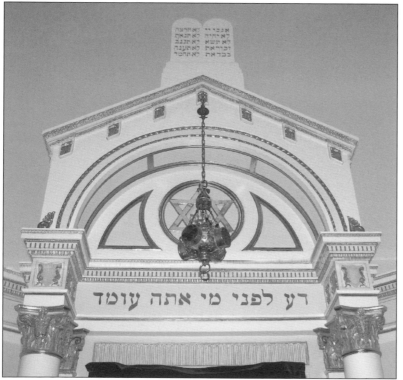

אנכי יי שאתרצח
לא יהיה לא תנאף
לא תשא לא תגנב
זכור את לא תענה
כבד את לא תחמד

דע לפני מי אתה עומד

The ark at B'nai Sholom's historic synagogue is an intricate architectural element with gold accents and is a focal point for the sanctuary. (Author's collection.)

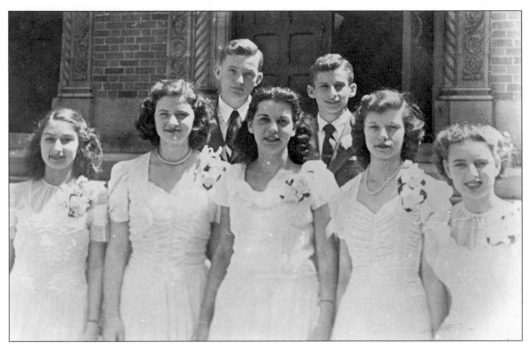

The 1945 Ohev Sholom Confirmation class gathers for a group photograph. Pictured from left to right are (first row) Lois Levy, Lillian Smolin, Sally Megeff, Phyllis Tobin, and Ellen Liepman; (second row) Jack Hyman and Bert Romer. (Courtesy of B'nai Sholom Congregation.)

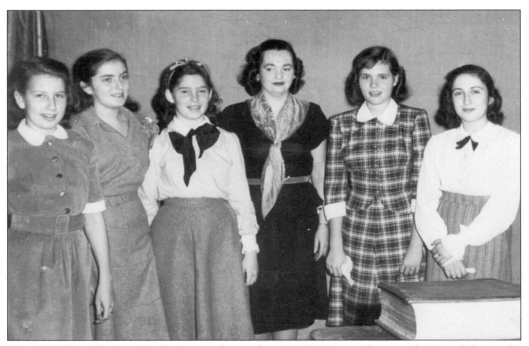

The 1949 Ohev Sholom Confirmation class is shown in this group photograph. From left to right are Maxine Feinberg, Lynette London, Margie Schradski, teacher Lela Kuntz, Marcia Saltz, and Annette Tannenbaum. (Courtesy of Marge Schradski Kakara.)

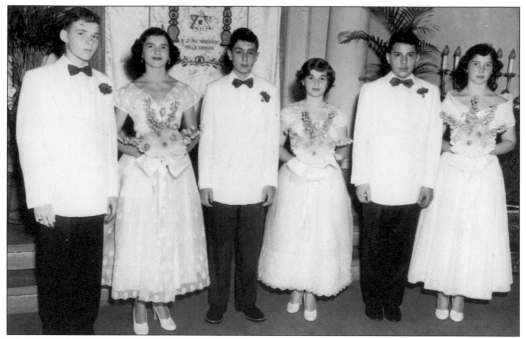

The rite of Confirmation was a staple in reform synagogues for many decades. Here the 1951 Confirmation class at Ohev Sholom poses for a photograph. From left to right are Robert Saltz, Carolyn Cohen, Chuck Broh, Carol Hayes, Martin Levy, and Margie Schradski. (Courtesy of Marge Schradski Kakara.)

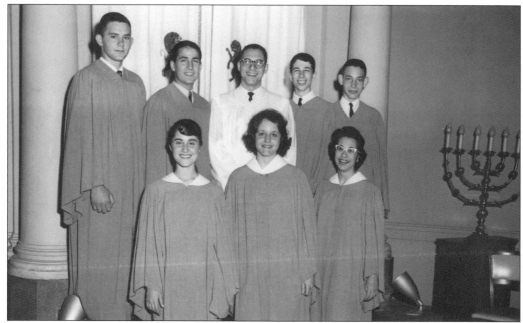

The 1961 Ohev Sholom Confirmation class gathers at the front of the ark in the sanctuary. From left to right are (first row) Carol Tarbis, Sydney Polan, and Jane Schoenfeld; (second row) David Silverman, Alan Frankel, Frank N. Sundheim, C. Anthony Broh, and David Sclove. (Courtesy of Tony Broh and Marge Schradski Kakara.)

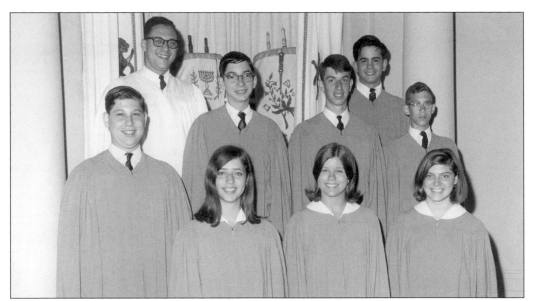

The Ohev Sholom Confirmation class of 1966 can be seen along with the Torahs housed in the ark in the sanctuary. Pictured from left to right are (first row) Allen Levy, Lois Ann Polan, Lynn Polan, and Candy Angel; (second row) Richard Kuntz, Ron Fallon, and Jeffrey Lake Smith; (third row) Rabbi Frank Sundheim and Paul Samson. (Courtesy of B'nai Sholom Congregation.)

The 1961–1962 Ohev Sholom religious school is pictured in front of the temple building in Huntington. (Courtesy of B'nai Sholom Congregation.)

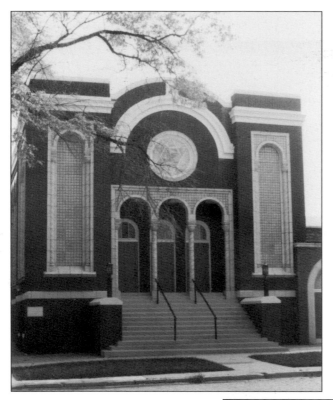

This photograph of the B'nai Israel synagogue on Ninth Street in Huntington was taken in 1978—the year that the congregation moved to Ohev Sholom's temple nearby on Tenth Street. The two congregations merged in 1974, but used both buildings until 1978. The former synagogue building is now used as a church. B'nai Israel dedicated their original synagogue on Ninth Street in 1924. (Courtesy of B'nai Sholom Congregation.)

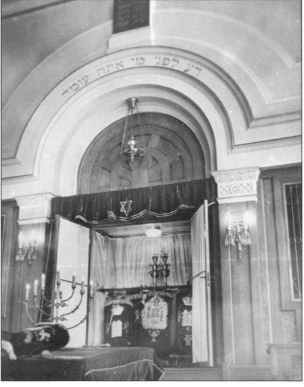

This 1940s photograph shows a close-up view of the classical style ark at B'nai Israel's synagogue. A replica of the ark and other items from the synagogue are now used in the small chapel of the B'nai Sholom synagogue on Tenth Street. (Courtesy of B'nai Sholom Congregation.)

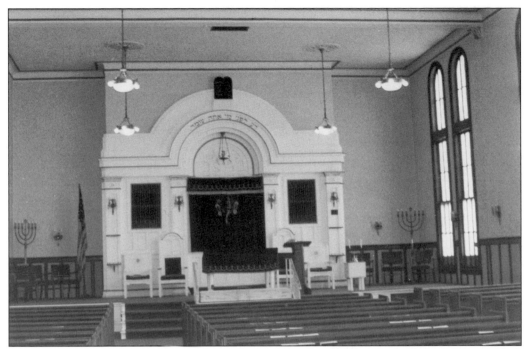

The interior of the B'nai Israel sanctuary is seen in 1978, the year that the building was vacated. A number of the stained glass windows had already been removed for use in the chapel at the merged congregation B'nai Sholom's temple building. (Courtesy of B'nai Sholom Congregation.)

The B'nai Israel religious school gathers for a photograph in 1962 in the social hall of the synagogue on Ninth Street. (Courtesy of B'nai Sholom Congregation.)

The B'nai Israel building committee gathers for a meeting in 1962. From left to right are Samuel Sweig, Jessie Katz, Jacob Herman, I. M. Bachrach, Ruth Steirn, Louis Gaffin, Betty Colker, and Jack Cuttler. B'nai Israel built a modern addition to their synagogue on Ninth Street to serve as space for the religious school and a social hall. (Courtesy of B'nai Sholom Congregation.)

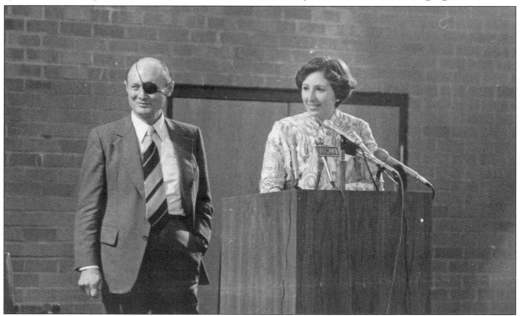

Moshe Dayan spoke to a standing-room-only crowd at Marshall University on February 20, 1977. He was introduced by Lynne Mayer, who coordinated the event sponsored by the local Jewish community and the Marshall University Foundation. The presentation was covered live statewide on public television, thanks to many private contributors. Dayan was an Israeli military leader, politician, and author. In 1977 he became Israel's foreign minister. (Courtesy of Lynne S. Mayer and B'nai Sholom Congregation.)

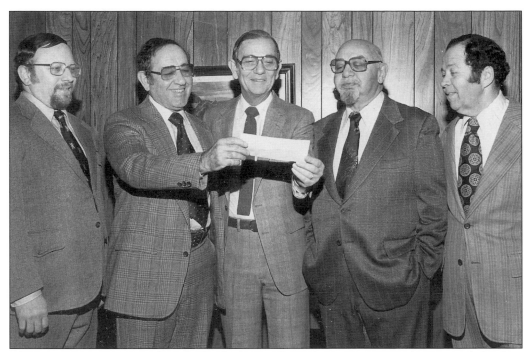

The Huntington B'nai B'rith Lodge leadership in the early 1970s presents their annual check to Dr. Bernard Queen of the Marshall University Foundation Scholarship Fund. (Courtesy of B'nai B'rith and B'nai Sholom Congregation.)

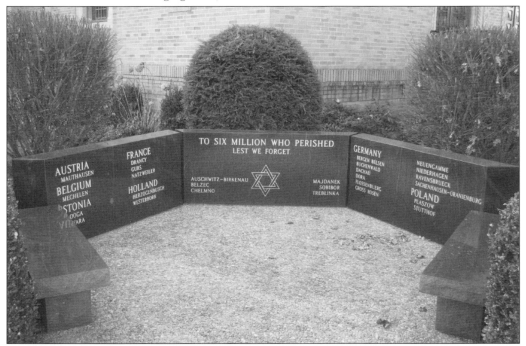

The B'nai B'rith Holocaust Memorial on the grounds of the B'nai Sholom synagogue in Huntington was dedicated on April 18, 1993. The memorial was a project of both the local B'nai B'rith chapter and the Huntington Jewish community. (Author's collection.)

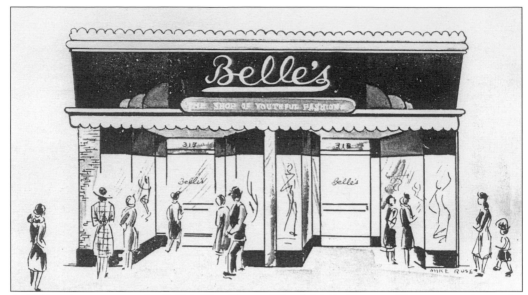

A 1950s advertisement for Belle's The Shop of Youthful Fashions in Huntington shows the modern exterior of the store. The store was established in 1936 by Maurice Rosen, who came to Huntington in 1914. (Author's collection.)

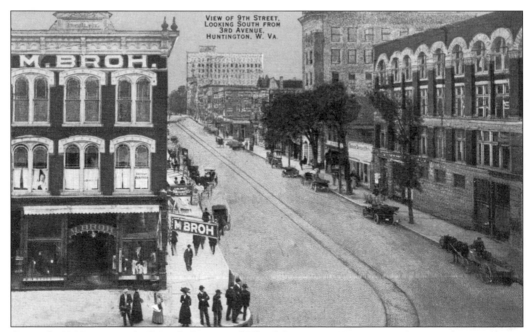

An early-1900s postcard of Ninth Street and Third Avenue in Huntington features the prominent building of the M. Broh clothing company. The Broh family was one of the earliest Jewish families in Huntington and was involved in a variety of retail and civic endeavors. (Courtesy of C. Anthony Broh.)

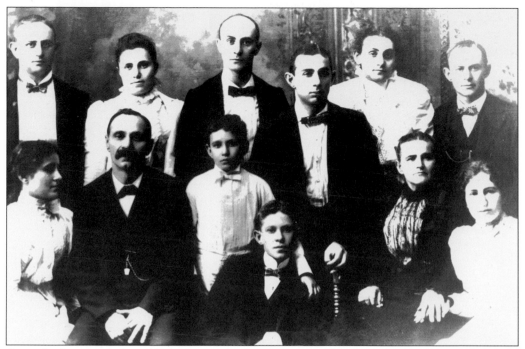

An early photograph from 1895 shows multiple generations of the Broh family. Mike Broh started a family clothing business in the city and became a well-known businessman and civic leader in Huntington. (Courtesy of C. Anthony Broh.)

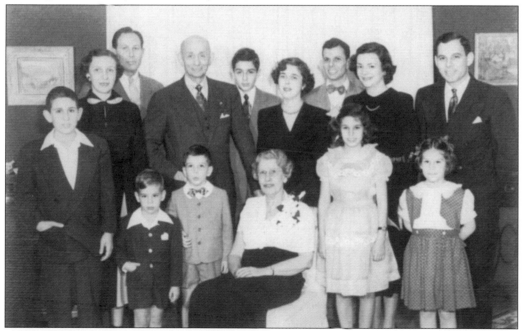

The Broh family gathers for a family reunion photograph in the 1950s. Pictured from left to right are (first row) Robert A., Eph Henry Jr., C. Anthony, Irene D., Sara Lynn, and Susan M. Broh; (second row) Adelle M., Adolph D., Eph, Charles M., Shirley M., Charles S., Elizabeth L., and Eph Henry Broh. (Courtesy of C. Anthony Broh.)

Charles S. and Shirley M. Broh are shown at their Huntington home in the 1950s with children C. Anthony (toddler), Charles M. (right), and Sara Lynn. (Courtesy of C. Anthony Broh.)

West Virginia Electric Supply Company was established in Huntington in 1935 by Charles Mandel. His nephews Herb and Joe Colker came to Huntington from Cincinnati in 1945 and built the company. This supply company and distributorship remains headquartered in Huntington, with eight other locations in West Virginia, Kentucky, and Ohio. It is the oldest existing Jewish-owned business in Huntington. The second location of the business in Huntington is shown in this 1944 photograph. (Courtesy of West Virginia Electric Supply Company.)

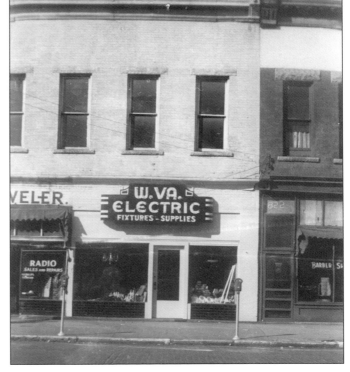

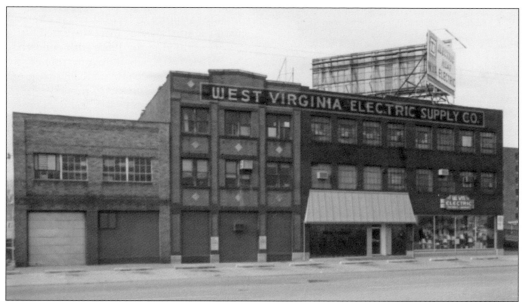

In 1950, the West Virginia Electric Supply Company moved to a much larger facility in Huntington. Shown here is a 1970s photograph of the building on West Twelfth Street. (Courtesy of West Virginia Electric Supply Company.)

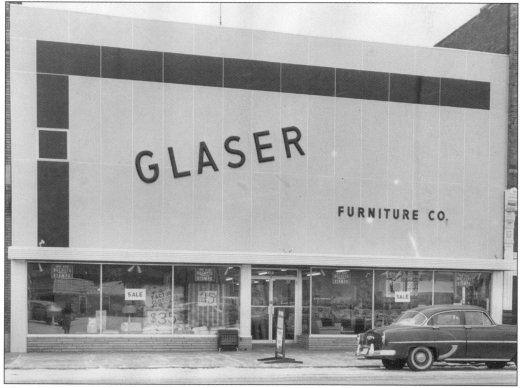

The newly remodeled storefront of Huntington's Glaser Furniture at 1931 Third Avenue is shown in 1960. The business was started in 1945 and is still run by the Glaser family. (Courtesy of Norman and Herman Glaser.)

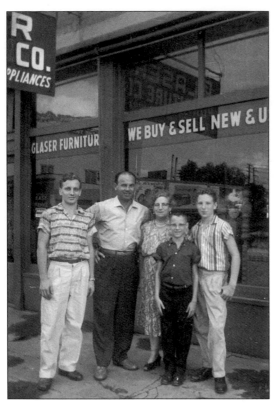

Glaser Furniture in Huntington is shown with the original storefront in 1957. This was how the exterior of the store appeared from 1946 to 1959. Standing in front of the store from left to right are Herman Glaser, Leo Aurback (Sam Glaser's cousin visiting from Israel), and Rachel, Simon, and Norman Glaser. (Courtesy of Norman and Herman Glaser.)

In 1951, Rachel and Simon Glaser pose for a family photograph with their sons Simon (left), Norman (center), and Herman. (Courtesy of Norman and Herman Glaser.)

In this 1940s postcard of Fourth Street in Huntington, Gold Furniture and Fetter Furniture are pictured on the left. Huntington had a large number of furniture stores that were owned and operated by members of the local Jewish community. Gold Furniture was established in 1924 by Samuel Gold, and Fetter Furniture was established by Maurice Fetter in 1911. (Author's collection.)

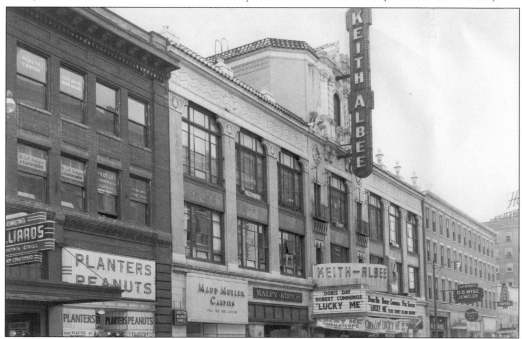

The Keith-Albee Theater on Fourth Street is pictured in this early-1950s photograph. Built by brothers Abe and Sol Hyman in 1928, the Keith was one of many large and opulent theaters built and operated by the family in Huntington. Beginning in 1912 with the Lyric Theater, the family pioneered motion picture theater operations in the city. The historic Keith-Albee is now owned by the Marshall University Foundation. The family still operates several theaters in the area under the direction of Derek Hyman and the Greater Huntington Theater Corporation. (Courtesy of Derek Hyman.)

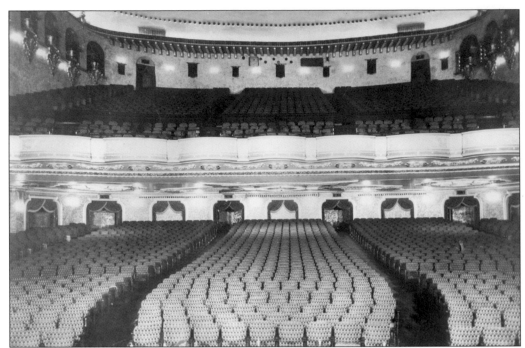

The ornate interior of the Keith-Albee Theater in Huntington was typical of the larger theaters built in many cities in the United States. (Courtesy of Derek Hyman.)

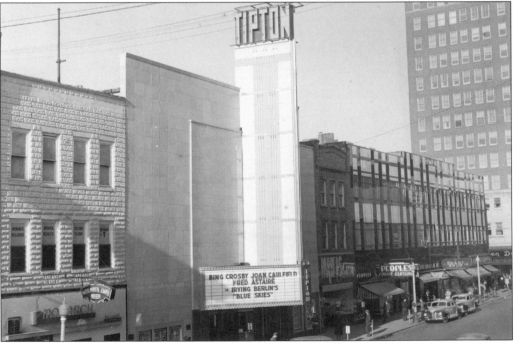

This 1947 view shows Tipton Theater in Huntington, which was built by the Hyman family. Cecil Tipton was Abe Hyman's right-hand man, and the family named the Tipton after him when he died unexpectedly. The Tipton Theater was destroyed by fire a few years later in 1951. (Courtesy of Derek Hyman.)

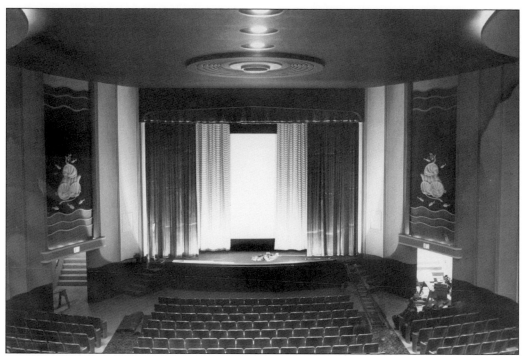

The clean, simple design of the Art Moderne interior of the Tipton Theater is seen shortly after the theater opened in 1947. (Courtesy of Derek Hyman.)

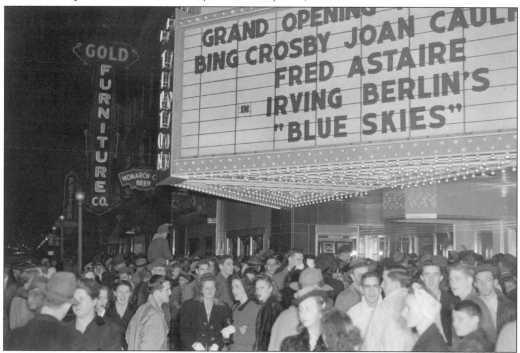

The marquee of the Tipton Theater announces the film *Blue Skies* starring Fred Astaire. Next door is a sign for the Gold Furniture Company, another business owned and operated by a local Jewish family. (Courtesy of Derek Hyman.)

A 1920 photograph features Rachel Levinson seated in a delivery truck advertising the Sixteenth Street Furniture Store. (Courtesy of Herman and Norman Glaser.)

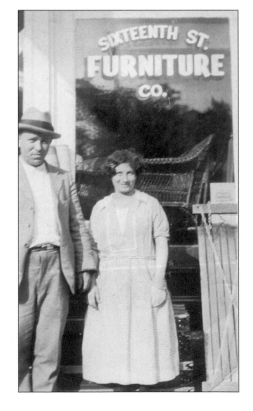

The Sixteenth Street Furniture Store was owned by Jake Levinson. His sister Rachel, who worked with him in the store, later met and married Sam Glaser while living in what is today the state of Israel. There they had two sons, Herman and Norman, before coming to Huntington. This 1920 photograph shows Jake and Rachel in front of the store. (Courtesy of Herman and Norman Glaser.)

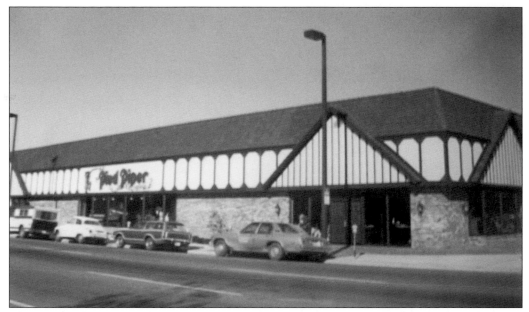

The new flagship store of the Pied Piper Music Store in Huntington opened in 1976. The business was started in 1967 by brothers Charles and Lawrence Levine, and the flagship store was considered a revolution in musical and audiovisual retailing. Branches were later opened in Barboursville, Beckley, and Charleston and also in Ashland, Kentucky. In 1998, a new store was built in suburban Charleston, and the Kanawha Mall store was closed. The main Huntington store closed in 2002, but the business is still operated by the Levine family. (Courtesy of Kevin Levine.)

Charles "Chuck" Levine established the Pied Piper with his brother Larry in 1967. (Courtesy of Kevin Levine.)

Lawrence "Larry" Levine was the co-owner of the Pied Piper family business with his brother Chuck. (Courtesy of Kevin Levine.)

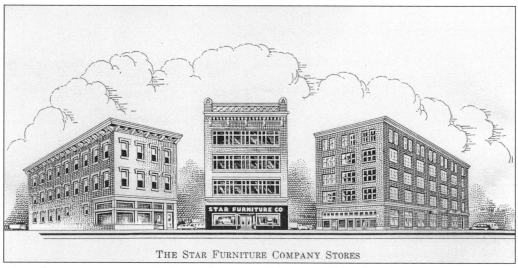

THE STAR FURNITURE COMPANY STORES

An early promotional sketch shows the various locations of the Star Furniture Company in Huntington. The business began in 1920, when Samuel Glick and his sons entered the furniture business. The company became known as Star Furniture in 1935 and expanded to several locations, as well as the Glick Colony House furniture store. The main Fourth Street store downtown closed in 1985, and all the remaining locations closed in the 1980s. (Author's collection.)

An early location of the State Electric Supply Company of Huntington is shown in this 1950s view. The company was established by Art Weisberg in 1952 when he began selling bulbs, fuses, and electrical cords on the road to grocery and hardware stores. The company is now one of the nation's best known and largest electrical supply distributors with 40 branch locations in five states. (Courtesy of Art and Joan Weisberg.)

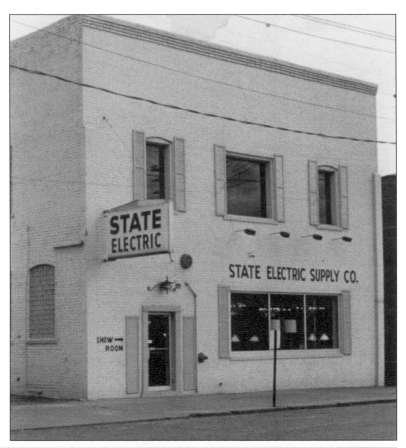

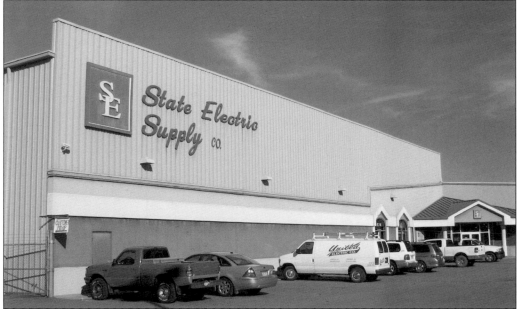

The current corporate headquarters of the State Electric Supply Company is located in an expansive state-of-the-art building on Second Avenue in Huntington. (Author's collection.)

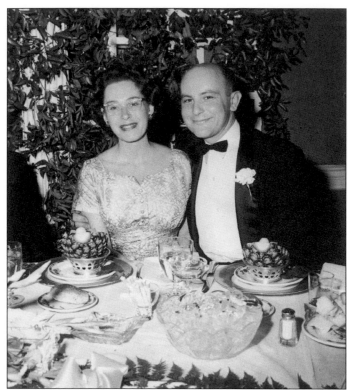

Art and Joan Weisberg are leading members of the Huntington Jewish community and the general community as well. They are shown here in a 1955 photograph at the wedding of Art Weisberg's brother, Fred. (Courtesy of Art and Joan Weisberg.)

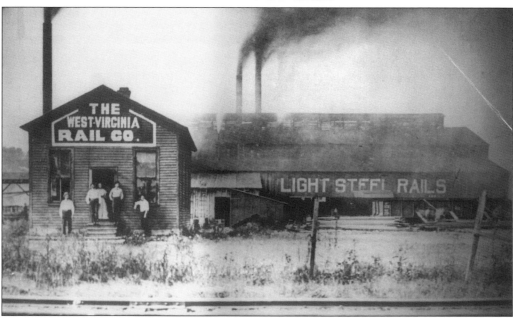

This is an early view of the original West Virginia Rail Company plant, which was located on the Ohio River in Huntington. The company was started in 1907 and acquired in 1909 by Joseph Schonthal, who greatly expanded the company and its facility. It was owned by the family until 1956. In 1982, the facility was re-purchased and renamed Steel of West Virginia, which today is a subsidiary of Steel Dynamics. (Courtesy of Steel of West Virginia.)

In 1910, the B'nai Israel Synagogue in Huntington was established under the leadership of Joseph Cohen. It was originally an orthodox congregation, but later adopted the conservative form of worship. (Courtesy of B'nai Sholom Congregation.)

Jules Rivlin was a basketball player at Marshall University in the late 1930s and coached there from 1957 to 1963. He was born in Wheeling, and he and his wife Esther lived there in the 1940s and 1950s. He also played professional basketball and is a member of the West Virginia Sports Hall of Fame. While in Huntington, he and his family were active members of the B'nai Israel Congregation. (Courtesy of B'nai Sholom Congregation.)

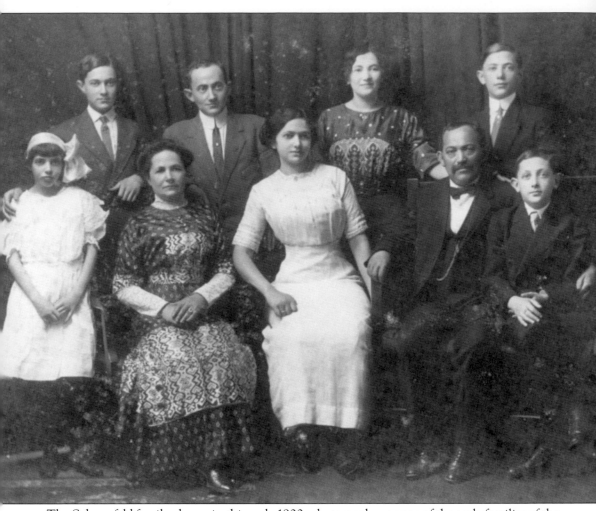

The Schoenfeld family, shown in this early-1900s photograph, was one of the early families of the original Ohev Sholom congregation in Huntington. (Courtesy of Marilyn Polan.)

Four

MARTINSBURG AND THE EASTERN PANHANDLE

Jews were living and operating clothing stores in Martinsburg as early as the 1870s. The Cohen, Fine, Katz, Kirson, Snyder, and Weil families were among the earliest Jewish families in town. Informal religious services were held sporadically in the early years, but it was not until 1912 that a more permanent and organized Jewish congregation was established. It would become known as Beth Jacob Congregation and was originally orthodox, but became reform by the 1950s. There were also a number of Jewish families in nearby Charles Town since the early 1900s, though they were never numerous enough to form a congregation. Most were members of the Martinsburg congregation.

The Jews of Martinsburg and Charles Town were engaged primarily in the retail sector, as was the case in so many locations. From the 1920s through the 1960s, Martinsburg's Queen Street was filled with a variety of Jewish-owned stores such as M. Cohen and Son, The Hub, Katz's, Diamond's, Lipsics, Kirson's, Garner's, and others. The Beth Jacob Jewish Cemetery was established in 1916.

Beth Jacob's first permanent home was the former United Brethren Church on Pennsylvania Avenue, which was used from 1912 to 1952. Their last home was a former funeral home on West Martin Street that was converted for use as a synagogue and formally dedicated in 1954. The Jewish community of Martinsburg was never large, but they had a visible presence due to their retail stores and also their civic involvement. The membership declined as people moved away and the younger generations looked for careers and family lives in larger Jewish communities in other states.

The congregation decided in 2007 to sell the synagogue building, and in 2009 the congregation was officially dissolved. Their assets were distributed among local organizations and the synagogues in Hagerstown and Winchester. Most Jews who live in the Eastern Panhandle are members of the Hagerstown, Maryland or Winchester, Virginia synagogues or they are unaffiliated.

Abraham Kaplon owned and operated a large department store in Harpers Ferry from 1900 until 1936. He served as mayor of Harpers Ferry and supervisor of streets and roads. Once he was established, he brought over most of his family from Lithuania and helped each of them get started with their own stores in Keyser and Romney and also in Brunswick, Maryland. Kaplon was a charter member of the local Odd Fellows Lodge. His store building was torn down in the 1950s, but his home still stands in town. (Author's collection.)

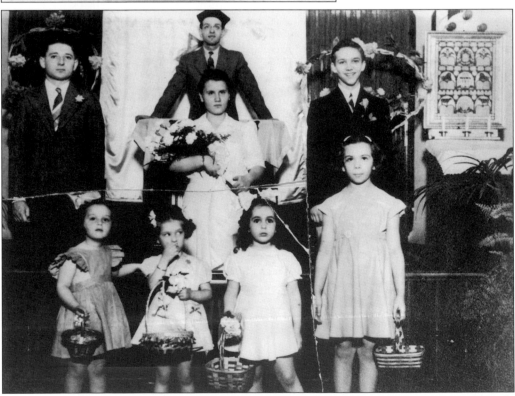

Martinsburg's Beth Jacob Congregation held a religious school consecration service in the early 1940s at their Pennsylvania Avenue synagogue. This rare photograph is one of very few in existence that show the interior of the old synagogue. (Courtesy of Georgia Katz DeYoung.)

Beth Jacob Congregation in Martinsburg dedicated their new synagogue building in 1954 and held a dinner and dance to celebrate the event. The previous building was a former church on Pennsylvania Avenue that was used from 1912 to 1952. (Courtesy of Jerry Kusner.)

The Officers and Board of Trustees

of

Beth Jacob Congregation

cordially invite you to the

Dedication Service and Dinner

Sunday evening, September 19, 1954

at Six o'clock

126 West Martin Street

Martinsburg, West Virginia

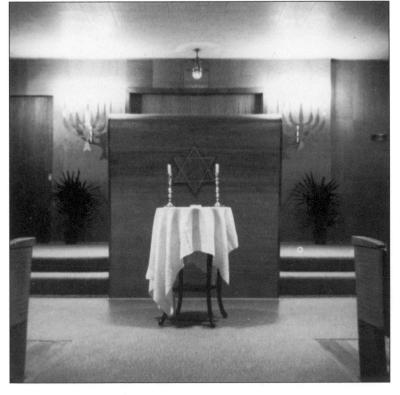

A 1950s view of the sanctuary interior at Beth Jacob shows the bimah, ark, and eternal light. The synagogue was furnished rather simply, but had beautiful stained glass windows on one side. The building was converted from a former funeral home to use as a house of worship. (Courtesy of Aaron Z. Snyder.)

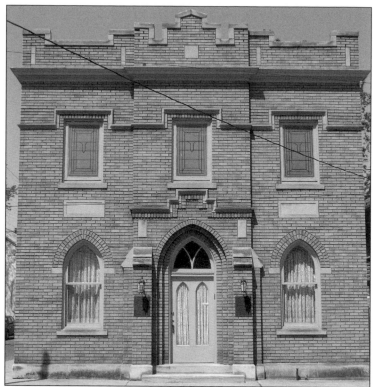

The exterior of the former synagogue of Beth Jacob Congregation on West Martin Street in Martinsburg is shown in this present-day photograph. The congregation was formally established in 1912, and they moved into their second synagogue in 1952. Because of the decline of Jewish residents in the area, Beth Jacob closed the synagogue in 2007, and in 2009 the congregation was officially dissolved and its assets distributed to charitable organizations. (Author's collection.)

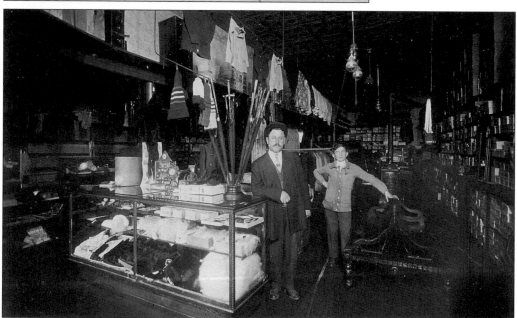

The interior of Martinsburg's M. Cohen and Son store on North Queen Street is seen in 1912. Begun in 1910 by Morris Mendel Cohen, it became one of the best-known higher-end ladies' fashion stores in the Eastern Panhandle. Mendel Cohen and his sons, Sol and Louis, became very involved in the retail and civic life of Martinsburg. (Courtesy Martinsburg-Berkeley County Public Library.)

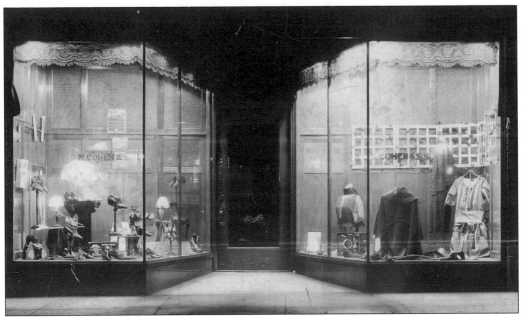

The newer location of M. Cohen and Son clothing store at 131–135 North Queen Street in Martinsburg is shown in 1920. The store also contained a beauty salon. Sol Cohen later constructed his home as a penthouse apartment on the top of the building. (Courtesy Martinsburg-Berkeley County Public Library.)

M. Cohen and Son's familiar slogan, "For That Cohen Look," is featured in a 1950s advertisement. The slogan was also featured on a sign painted on the side of their Queen Street building. That sign is still visible today and is a testament to one of the early Jewish families in Martinsburg. (Author's collection.)

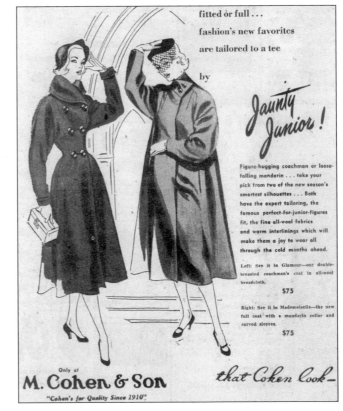

fitted or full . . .
fashion's new favorites
are tailored to a tee
by

Jaunty Junior !

Figure-hugging coachman or loose-falling mandarin . . . take your pick from two of the new season's smartest silhouettes . . . Both have the expert tailoring, the famous perfect-for-junior-figures fit, the fine all-wool fabrics and warm interlinings which will make them a joy to wear all through the cold months ahead.

Left: See it in Glamour—our double-breasted coachman's coat in all-wool broadcloth.

$75

Right: See it in Mademoiselle—the new full coat with a mandarin collar and curved sleeves.

$75

Only at
M. Cohen & Son
"Cohen's for Quality Since 1910"

that Cohen look—

Sol Cohen and daughter Nadia Cohen Elins joined others in 1967 at a reception celebrating the signing of the contract for the new library in Martinsburg. Both were instrumental in making the new library a reality. Sol and Louis Cohen established the Berkeley Upholstery Company in the 1920s, and the Cohen and Elins families supported many area projects and causes. (Courtesy of Martinsburg-Berkeley County Public Library.)

Diamonds

SMART FASHIONS

LADIES SHOPS: 155 North Queen Street, Martinsburg, West Virginia
 230 West Washington Street, Charles Town, West Virginia

GIRLS SHOP: 153 North Queen Street, Martinsburg, West Virginia

BOYS SHOP: 100 East Martin Street, Martinsburg, West Virginia

"THE NICEST SHOPS IN TOWN"

Diamond's was a local clothing store in Martinsburg with a branch in nearby Charles Town. The business was established by Gene and Bernice Diamond. Gene Diamond served one term as mayor of Martinsburg from 1972 to 1978. (Author's collection.)

This is a 1950s newspaper advertisement for Garner's Ladies' Shop, which was located on Queen Street in Martinsburg. The business was started in 1914 by Emanuel Garner and known as E. Garner's Specialty Shop. It was later operated by Emanuel's son Julius and his wife, Lillian, and was in business at least until 1979. (Author's collection.)

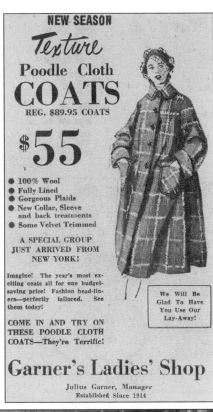

NEW SEASON

Texture

Poodle Cloth

COATS

REG. $89.95 COATS

$55

- 100% Wool
- Fully Lined
- Gorgeous Plaids
- New Collar, Sleeve and back treatments
- Some Velvet Trimmed

A SPECIAL GROUP JUST ARRIVED FROM NEW YORK!

Imagine! The year's most exciting coats all for one budget-saving price! Fashion head-liners—perfectly tailored. See them today!

COME IN AND TRY ON THESE POODLE CLOTH COATS—They're Terrific!

We Will Be Glad To Have You Use Our Lay-Away!

Garner's Ladies' Shop

Julius Garner, Manager
Established Since 1914

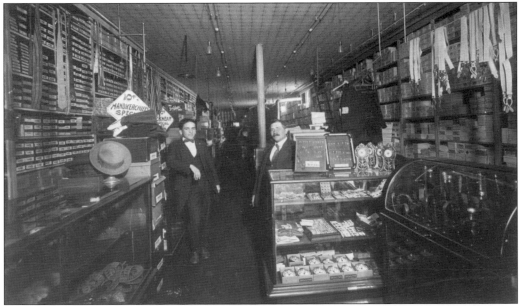

The interior of The Hub on Queen Street in Martinsburg is seen here prior to 1919. Begun in the late 1890s by Aaron Cecil Snyder, the popular men's clothing business was later run by his son, Perry Snyder, and closed in 1964. Aaron Snyder was a partner with Charles Fine in the Fine-Snyder New York Clothing House on Queen Street in the 1890s. That partnership was dissolved in 1895, after which Snyder started The Hub. (Courtesy of Aaron Z. Snyder.)

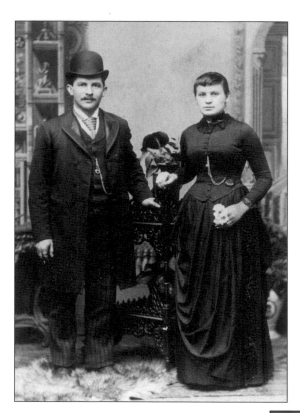

Aaron Cecil Snyder and his bride, Sarah Samet of Martinsburg, were married in Latvia. They are seen here in their wedding photograph. (Courtesy of Aaron Z. Snyder.)

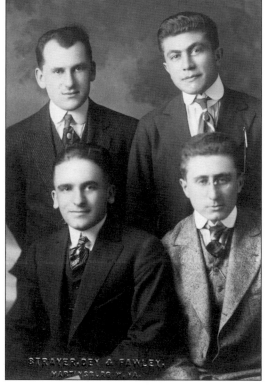

An early 1900s portrait studio photograph features Perry Snyder at bottom left and the Fine brothers, Nathan (above right) and Reuben (bottom right). The Fine family was an early Jewish family in Martinsburg. (Courtesy of Aaron Z. Snyder.)

Perry Snyder appears in his World War I uniform. The Cohen, Fine, Katz, and Snyder families of Martinsburg all had sons who served in the war. Their names are inscribed on the war memorial on King Street downtown. (Courtesy of Aaron Z. Snyder.)

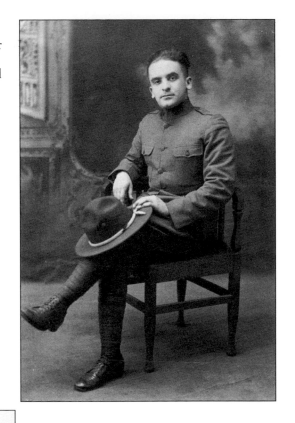

BUY YOUR

Clothing

⊚ Dry Goods

and Shoes

from the Cheapest Store in town, and you are sure to get Bargains at the

BOSTON ONE-PRICE CLOTHING HOUSE,

GEORGE KATZ & CO., Proprs.

75 N. QUEEN STREET.

The George Katz and Company Boston One Price Clothing House in Martinsburg was started in the 1890s by George Katz and was one of the earlier Jewish businesses in the city. It evolved into one of Martinsburg's largest department stores. (Author's collection.)

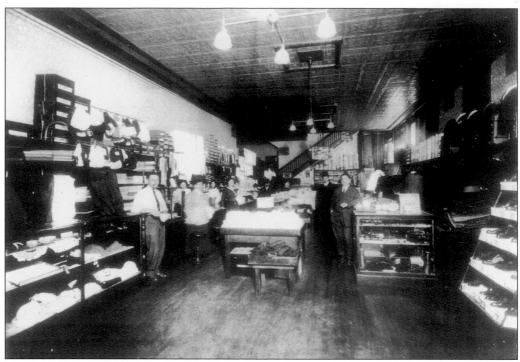

George Katz and son Allen B. Katz are shown in the interior of the family store in the early 1920s. (Courtesy of Georgia Katz DeYoung.)

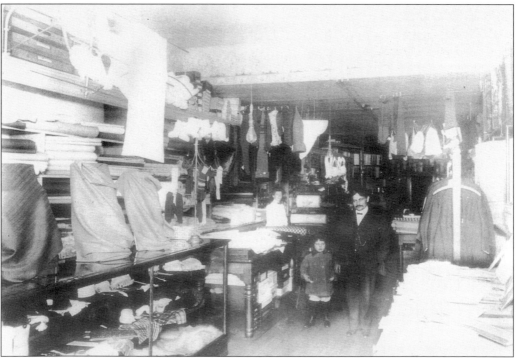

An early-1930s interior view shows the remodeled men's department at George Katz and Son Department Store in Martinsburg. (Courtesy of Georgia Katz DeYoung.)

The exterior of the George Katz and Son store on Martinsburg's Queen Street is seen in the 1950s. One of the more popular stores in town, it was built in the early 1900s and sold all manner of clothing and household goods. It had a famous bargain basement and the first store escalator in town. The family sold the store in 1963, and it went out of business shortly thereafter. (Courtesy of Georgia Katz DeYoung.)

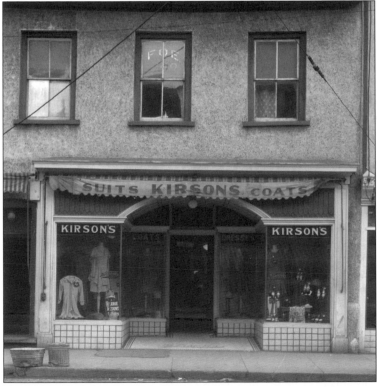

Kirson's women's clothing store on North Queen Street is pictured in the early 1920s. Kirson's was established by Noah Kirson in the late 19th century and was one of the first Jewish stores in Martinsburg. Noah's son, Wolf, ran Kirson's Men's Store, also on North Queen Street. There was also a Kirson family run store in Waynesboro, Pennsylvania. (Courtesy of West Virginia and Regional History Collection West Virginia University Libraries.)

ESTABLISHED 1864.

Ready-Made Clothing

For Men, Boys and Children.

Hats, Caps, Trunks, Valises
and Gent's Furnishing Goods.

It is a fact acknowledged, that David Weil's store is the place
to find the largest, best and cheapest variety of Clothing,
Hats, Caps and Gent's Furnishing Goods in this end
of the state. The stock embraces everything in
our line, and at prices that defy competition.

Call to see us before purchasing, and
our word for it, it will pay you well.

DAVID WEIL,

A late-1890s newspaper advertisement for David Weil's ready-made clothing store for men, boys, and children was typical of advertising for the period. The Martinsburg business was established in 1864 by brothers David and Moses Weil. The Weil family, originally from Bavaria, was among the first Jewish families in Martinsburg. By the 1920s they were no longer in Martinsburg, but had relocated to Morgantown, where they also operated clothing stores. (Author's collection.)

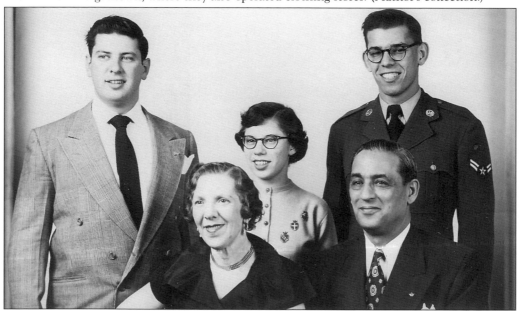

Lillian and Louis Kusner are pictured in the early 1950s with their children Jerry (left), Clarissa Jean, and Edwin. Lou Kusner came to Martinsburg in 1932 to manage the two Warner Brothers theaters in town. He was active in war efforts and also was active at Beth Jacob. Son Jerry Kusner is one of the last of the older Jewish families to still live in Martinsburg. (Courtesy of Jerry Kusner.)

The Hyman Kaplon family was a large and influential family in Keyser. Shown from left to right are (first row) Bertha Kaplon, Mera Kaplon holding Beatrice Werble, Hyman Kaplon holding Wallace Werble, and Hannah Kaplon; (second row) Sarah Kaplon Werble, Moses Kaplon, unknown, Edna Kaplon, and Susan Kaplon. (Courtesy of Gilda Kurtzman.)

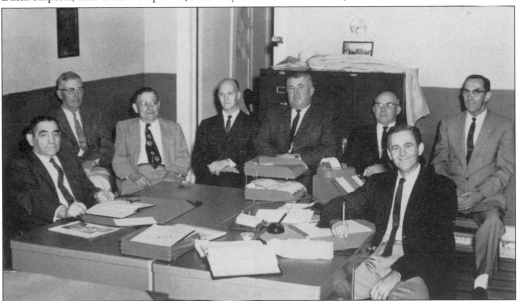

David Shear served as a nine-term mayor of the town of Romney. The Shear family was well known in town and operated Shear Department Store since 1919. They were originally from Poland and came to Romney in 1907. David Shear was first elected to the town's council in 1933 and served his first term as mayor in 1951.

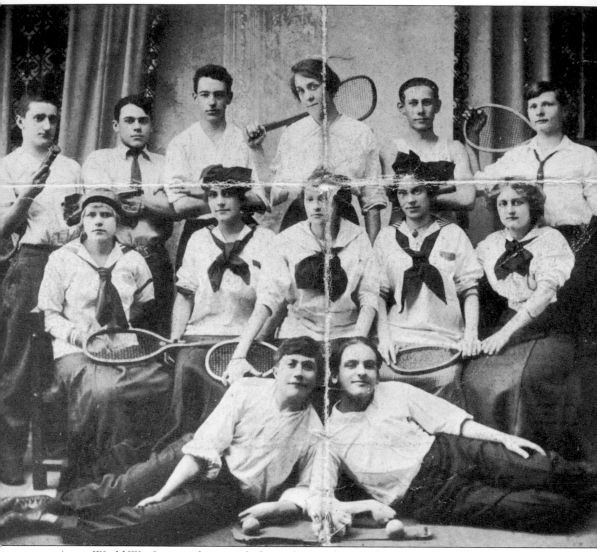

A pre–World War I group photograph shows the members of the popular tennis club at Martinsburg High School. Shown reclining in the photograph is Perry Snyder on right and Nathan Fine on the left. The story is told that neither one played tennis, but were called upon to fill in space in the group photograph. (Courtesy of Aaron Z. Snyder.)

Five

CLARKSBURG AND MORGANTOWN

The first permanent Jewish settler in Clarksburg was David Davidson, who arrived prior to 1861 and opened a clothing store. The Nusbaum family came in 1880 and operated a successful clothing business. B'nai B'rith Lodge 727, formed in 1913, was an early Jewish organization in the city. Clarksburg's Jewish congregation, established around 1917 as an orthodox congregation, became the Tree of Life congregation in 1922. It adopted the conservative worship style in 1939 upon merging with the reform Temple Emanuel (established around 1914). A former Presbyterian church on West Pike and Fifth Streets was purchased as a synagogue in 1939. In 1955, the congregation dedicated a small Jewish community center adjacent to the synagogue. Clarksburg had active chapters of Hadassah, a B'nai B'rith Lodge, and a very active sisterhood. The community established their Jewish Memorial Cemetery in nearby Bridgeport.

The Jews of Clarksburg were engaged primarily in retail trades. There were many Jewish businesses in Clarksburg, including Adler's, Broida's, Friedlander's, Nusbaum's, Rosen's, Style Shop, The Men's Shop, and others. Many of the Jewish families were well respected in the community. The Jewish population of Clarksburg declined in the 1970s and 1980s, and by 2004 the synagogue was closed and sold, as there were only a few Jewish families left.

Morgantown's Tree of Life synagogue was incorporated in 1922 though an informal Jewish congregation existed a few years earlier. The local B'nai B'rith Lodge was formed by 1916 and was probably the first Jewish organization in Morgantown. By 1927, the Hillel Jewish student group at West Virginia University was organized, and some years later they dedicated a building at 1420 University Avenue.

From its founding until about 1949, the Tree of Life Congregation did not have a permanent synagogue. At that time, the congregation built their modern synagogue at 242 South High Street. In recent years as Fairmont's Beth El and Clarksburg's Tree of Life synagogues closed, many members of these former congregations joined the Morgantown congregation. There is a Jewish cemetery in Morgantown with sections for the Morgantown Tree of Life and also for Fairmont's former Beth El Congregation.

The retail sector and university provided opportunities for the success of members of the local Jewish community. The DeLynn family owned and operated the Fashionable Shoe Store and Floradora Shoppe for decades. Richard's, a children's and women's clothing store, was owned by Hilda and Richard Rosenbaum for many years. Both families are well known as philanthropists in Morgantown. Other well-known Jewish stores were Sidler's, Weintrob Brothers, Caplan's, Finn's, The Yardstick, Royal Furniture, Kaufman's, The Princess Store, The People's Store, and Saul's Dollar Store.

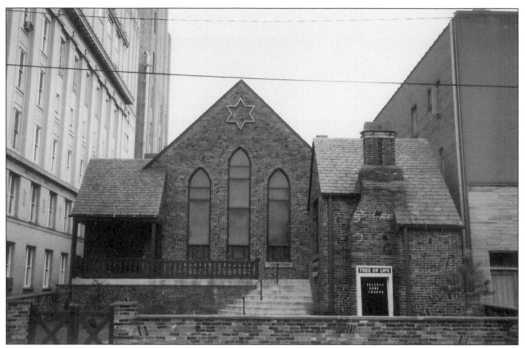

Clarksburg's Tree of Life Congregation was established around 1917 as an orthodox Jewish congregation. Clarksburg at one time had a large Jewish population, but a steady decline in Jewish population numbers forced the synagogue to close in 2004. There are tentative plans to turn the former synagogue into an arts center. (Author's collection.)

This 1989 exterior view of the Tree of Life synagogue in Clarksburg was taken while the congregation was still active. (Author's collection.)

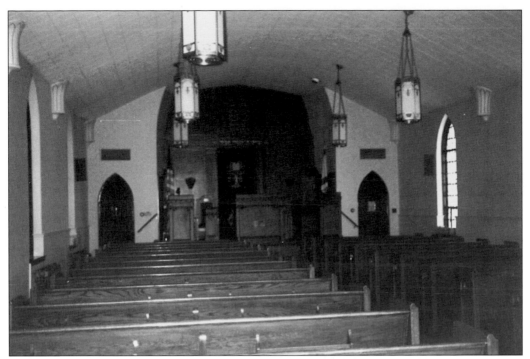

This 1970s interior view of the sanctuary of the Tree of Life Synagogue shows a view towards the ark and bimah. The synagogue was originally built as a Presbyterian church in 1881. (Courtesy of Bill Adler.)

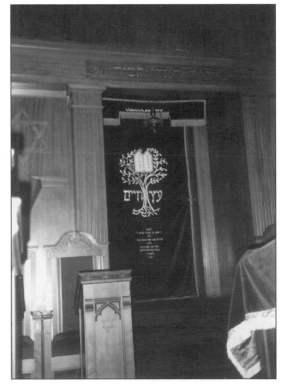

The ark in the sanctuary of the Tree of Life Synagogue was a beautiful feature of the interior. (Courtesy of Bill Adler.)

Broida's was a higher-end women's clothing store in Clarksburg. The Broida family also operated a store in Parkersburg, which was purchased by the Stone and Thomas Department Store of Wheeling in 1956. The Clarksburg store closed some years ago. (Author's collection.)

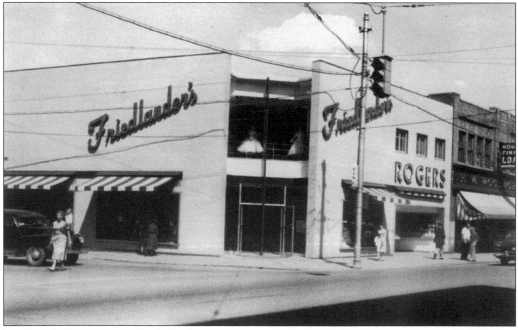

Friedlander's was a popular ladies' ready-to-wear store on Fourth Street in Clarksburg. It was established by Max Friedlander and later operated by Albert Rosen. (Courtesy of Tim Cork.)

Nusbaum's was an early men's clothing business in Clarksburg that experienced growth and expansion from its humble beginnings. Several members of the Nusbaum family, who came to Clarksburg in 1880, owned stores in town. Shown here is the Nusbaum building in an early postcard image. (Courtesy of Tim Cork.)

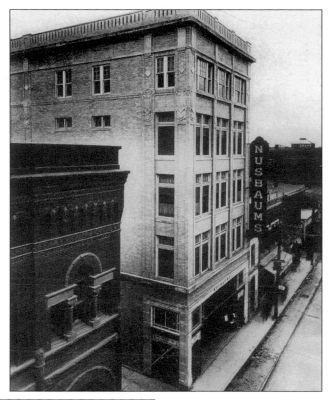

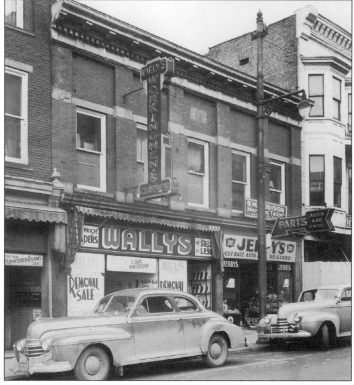

A late-1930s view shows the exteriors of Wally's, a workingman's clothing store, and Jerry's auto parts store in Clarksburg. Wally's was established by the Adler family and was in operation until about 1945. The family then opened Adler's men's clothing store, which was in operation until the family relocated to Arizona in 1953. (Courtesy of Bill Adler.)

Doing Our Own Thing —
Is Helping You to
Make the Scene

THE
WORKINGMANS
STORE

Men's Clothing for Every
Season, Every Need

328 West Pike Street
Clarksburg, W. Va.

The Workingman's Store on Pike Street in Clarksburg was operated by the Berman family as early as 1933. The store was still in business in the early 1970s. (Author's collection.)

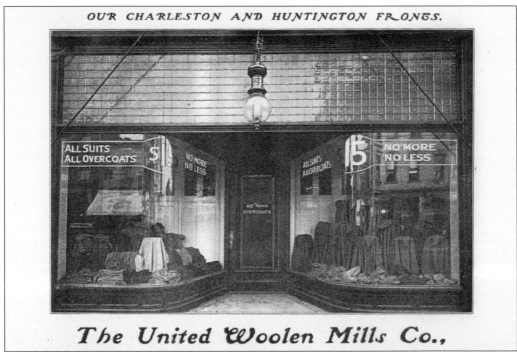

OUR CHARLESTON AND HUNTINGTON FRONTS.

ALL SUITS
ALL OVERCOATS $ NO MORE
 NO LESS

ALL SUITS
ALL OVERCOATS 15 NO MORE
 NO LESS

WE MAKE
OVERCOATS

The United Woolen Mills Co.,

An early-1900s advertisement for the United Woolen Mills stores shows how the store exteriors looked. The chain was owned and operated by W. A. Hersch of Parkersburg and had locations in Clarksburg, Charleston, Huntington, and Parkersburg. (Author's collection.)

Morgantown's Tree of Life synagogue has been located on South High Street since 1949. The congregation was originally orthodox in worship style, but by the 1940s had adopted the reform worship service. It is an active congregation today. (Courtesy of Dan Shane.)

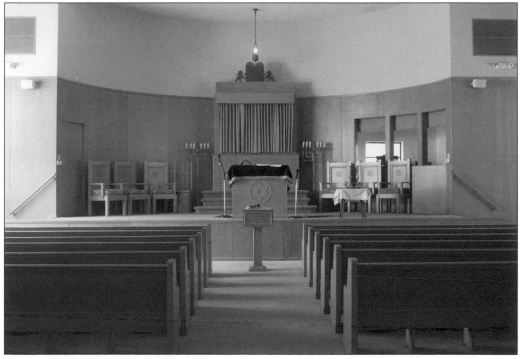

The sanctuary interior of the Tree of Life synagogue in Morgantown features simple mid-century modern detailing. (Courtesy of Edward Gerson.)

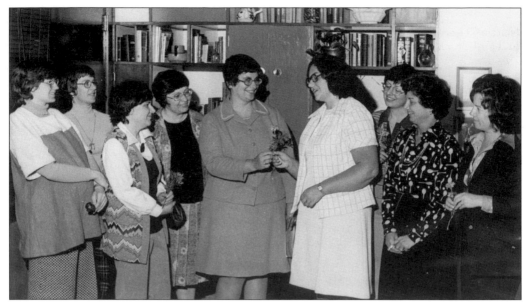

Hadassah is a nationwide women's membership and charitable organization with a focus on health, education, youth, and the environment. Pictured at the installation of the 1975 officers of the Morgantown chapter are, from left to right, Sarah Reis, Charlotte Lawrence, Edith Levy, Charlotte Dines, Rosalie Opall (installing officer from Hadassah's Uniontown, Pennsylvania chapter), Sylvia Cooper, Linda Jacknowitz, Vivian Goldstein, and Zulie Jacobsohn. (Courtesy of Sylvia Cooper.)

Early 1970s chapter officers gather for a group photograph. Pictured from left to right are Linda Fenton, Margie Klapper, Denda Jenks, Judy Cohen, Linda Jacknowitz, Zulie Jacobsohn, and Dianne Goldberg. It remains an active chapter group. (Courtesy of Sylvia Cooper.)

Pictured in 1959, Charleston's Marcia Jo Koenigsberg (president) and Malcolm Kerstein (vice-president) were Jewish students who became involved in Jewish campus activities at the University of West Virginia's Hillel Foundation. Both were from Charleston. Hillel, located at 1450 University Avenue in Morgantown, was the center for Jewish cultural and social activities. It still serves as an active center for Jewish students today. (Courtesy Marcia Koenigsberg Zerivitz.)

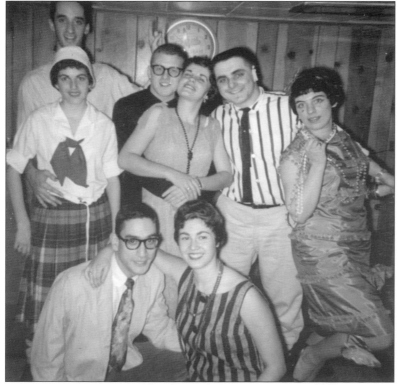

West Virginia University Jewish fraternity Phi Sigma Delta held a Roaring 20s party at the fraternity house in Morgantown in 1959. Pictured from left to right are (first row) Malcolm Kerstein and Marcia Koenigsberg (Zerivitz); (second row) David Joel, Karen Markham, Eddie Weisberg, unknown, Gordon Sherman, and unknown. (Courtesy Marcia Koenigsberg Zerivitz.)

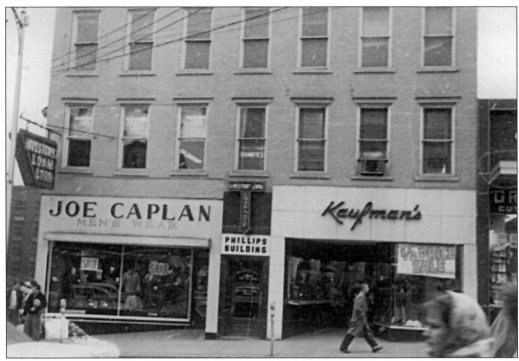

Caplan's and Kaufman's clothing stores are featured in this 1960s photograph in downtown Morgantown. Caplan's was operated by Joseph Caplan. (Courtesy of Morgantown History Museum.)

Still a Good Selection of Real
BARGAINS
In Men's Wear at Caplan's
Smoke Sale
Which Continues This Week

Positively Nothing held back - - Everything MUST be Sold! All brand new merchandise -- Not damaged by fire or water! Suits, Sport Coats, Slacks, Jackets, Sport Shirts, Dress Shirts, Sweaters, Shoes, Neckwear, Underwear, Hats, etc. -- and some items as much as ½ price! Hurry and Save!

Reductions
As Much
As - - - - -

1/2 off

All
Sales
Final!

Open Tonight Till 9:00

CAPLAN'S
Corner High and Walnut Sts.

A 1958 newspaper advertisement for Caplan's menswear in Morgantown features bargains prior to a fire at the store. (Author's collection.)

Many Jewish businesses advertised in local high school yearbooks, such as this 1964 Morgantown High School ad for the Royal Furniture Company. Located on High Street downtown, the store was owned and operated by Samuel W. Stein beginning around 1924. His son-in-law, Harold R. Weiss, later ran the business. (Author's collection.)

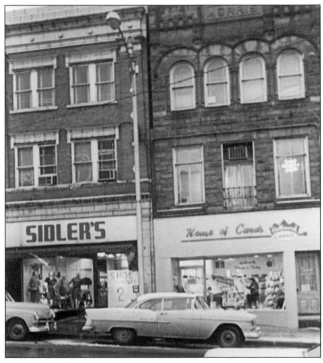

Here is a 1950s exterior view of Sidler's, a women's clothing store downtown owned and operated by the late Milton Cohen and his wife, Bertha. Milton was originally from Pennsylvania, but he and his family lived in Morgantown since the 1920s. Milton Cohen was well known in Morgantown and was active in business and political circles. He and his wife owned and operated Sidler's from 1946 to 1983. (Courtesy of Morgantown History Museum.)

THE BOSS IS AWAY ... AND WE'VE GOT TO EARN OUR PAY!

— HURRY DOWN FOR SOME REAL VALUES —

We're Wheelin' and Dea lin'-Save 50% and More!

HERE ARE JUST A FEW TERRIFIC BARGAINS OFFERED:

Hollywood Bed Outfits • Innerspring Mattress • Box Spring • Headboard • Legs **$39⁹⁵**	3-Pc. Bedroom Suites **$79⁵⁰**	Living Room SUITES **$99⁵⁰**

COHEN'S

FURNITURE CO.
154 Pleasant Street
PHONE 3556
--EASY TERMS!--

Cohen's Furniture Company in Morgantown was offering bargain prices in this 1958 newspaper advertisement. The business closed prior to 2005. (Author's collection.)

Six

PARKERSBURG

Parkersburg is similar to Huntington, Charleston, and Wheeling in that it had an early settlement of Jewish residents in the city. The first Jewish families were there in the 1850s, and by 1869 the Parkersburg Young Men's Hebrew Association (YMHA) had been organized. In the late 1890s and early 1900s, there existed a Zion Society, the Ladies' Temple Society, the Ladies' Sewing Society, the Hebrew Aid Society, and the Progress Club. It appears that the YMHA conducted reform Jewish worship services until about 1888. There was also a Jewish Sunday school, but no formal Jewish congregation with a building.

It was not until 1909 that a meeting was held at the United Woolen Mills building to create a formal Jewish congregation, B'nai Israel, in Parkersburg. Some of the early members of B'nai Israel were the Hersch, Lasky, Berens, Goldstein, Salinger, Engleman, Kirstein, Kahn, Stern, Epstein, Barrett, Cohen, Setron, Reitzenberg, Oppenheimer, Levison, and Broida families. Parkersburg Lodge 767 of B'nai B'rith was organized in 1915. When the congregation was first organized there was a motion to build a temple, but this did not occur, and until the first temple building of B'nai Israel was dedicated in 1949, the congregation worshiped in several locations. The new temple was located at 1703 Twentieth Street, which remains the current home of the congregation. There is a consecrated Jewish cemetery section at the Mount Olivet Cemetery in Parkersburg.

The early Jews of Parkersburg were store and business owners, and this has been true up to the present time, though the number of Jewish-owned businesses in Parkersburg has declined sharply since the city's heyday. Today the only Jewish-owned businesses in town are Mister Bee's, a snack food maker; Kreinik Manufacturing, an importer and maker of silk and metallic threads that was established in the 1970s; and Gatewood Products, which was started in the 1940s by Ted Gateman. There are also several Jewish attorneys and physicians in town today.

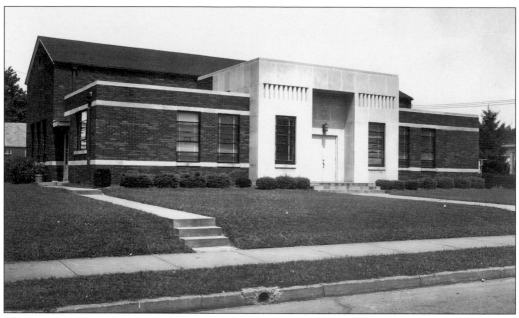

The exterior of the B'nai Israel Congregation synagogue on Twentieth Street in Parkersburg is seen shortly after it was built in 1949. (Courtesy of Paul Borelli and Artcraft Studio.)

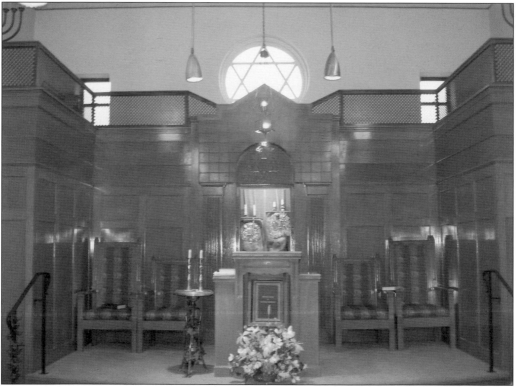

The Mid-Century Modern style sanctuary at B'nai Israel Congregation in Parkersburg features polished dark wood accents in this view toward the choir loft, bimah, and ark. (Courtesy of Myla Kreinik and B'nai Israel Congregation.)

This is an early location of Broida and Adams store, which was located at 427 Market Street in downtown Parkersburg in 1907. The store carried women's clothing, dry goods, and furnishings. The Jacob Broida family were early Jewish residents of Parkersburg and were among the founding families of B'nai Israel. (Courtesy of Paul Borelli and Artcraft Studio.)

Broida and Adams moved to a newer location at 515 Market Street prior to World War I. (Courtesy of Paul Borelli and Artcraft Studio.)

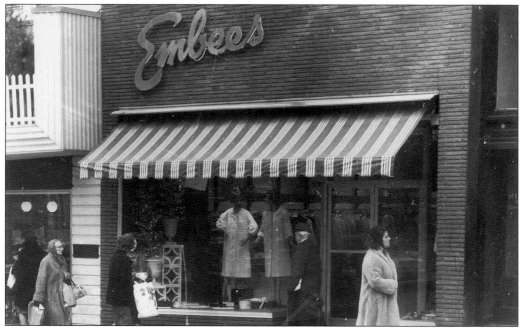

Embee's branch store in Parkersburg is seen in this 1960s view. Embee's was a large women's clothing store established by brothers Abe and Isidore Margolis. The West Virginia chain also had stores in Beckley, Charleston, Hurricane, Logan, and Montgomery (National Shop). The chain is no longer in existence. (Courtesy of Paul Borelli and Artcraft Studio.)

"Authority for Men's Correct Dress."

Charles Epstein,

Merchant
Tailor

A reputation built upon fifty years of successful experience.

TWO HUNDRED AND FOUR
UNION TRUST BUILDING, (Second Floor)
PARKERSBURG, W. VA.

Charles Epstein was an early Jewish resident of Parkersburg, arriving in the 1860s. An early-1900s business card advertises his expertise and the fact that he was a longstanding business in town. (Author's collection.)

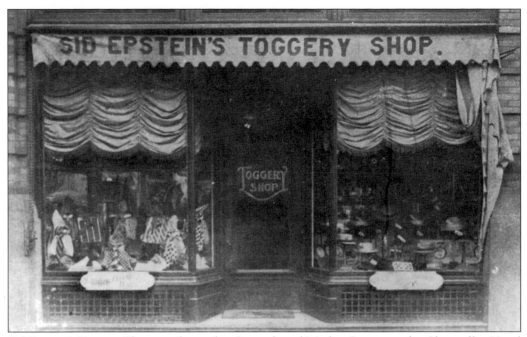

Sid Epstein's Toggery Shop was located at Seventh and Market Streets in the Chancellor Hotel building in Parkersburg. The display windows of the store are featured in this 1907 photograph. (Courtesy of Paul Borelli and Artcraft Studio.)

Goldenberg Furniture Company on Market Street is shown after business resumed following the 1937 flood. The Parkersburg store was begun by two of Abe Goldenberg's brothers a few years after Abe opened the first Goldenberg store in Somerset, Kentucky in 1904. Before Goldenberg closed their Somerset store in 2009, it was the oldest existing locally owned business in Pulaski County. The Parkersburg store later became Gershman's Ethan Allen Galleries. (Courtesy of Paul Borelli and Artcraft Studio.)

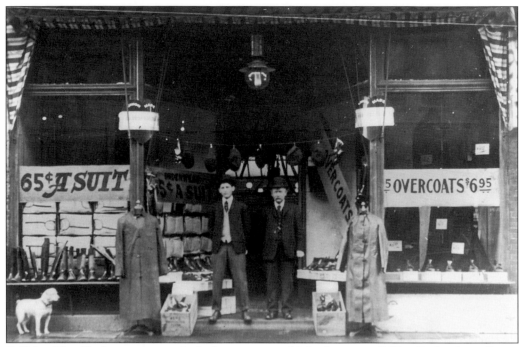

S. Kahn The Clothier was a men's clothing store established prior to 1907 in Parkersburg. It was located at 311 Market Street around 1924, but it is not known how long the store was in business. (Courtesy of Paul Borelli and Artcraft Studio.)

This is a 1937 view of Laskey's as it appeared just after the infamous Parkersburg flood of the same year. It was established by Irving Laskey at 315 Market Street prior to 1922. It is not known how long this store was in business or when it closed. (Courtesy of Paul Borelli and Artcraft Studio.)

The exterior of the Mister Bee's potato chip plant and office is pictured in the 1950s around the time the large facility was built. Established in 1951 by Leo and Sarah Klein, the business is now a multi-million-dollar company operated by Leo and Sarah's son, Alan. Mr. Bee's is a regional firm serving West Virginia and parts of Ohio and Kentucky, and is the only potato chip made in the Mountain State. (Courtesy of Paul Borelli and Artcraft Studio.)

Sid's Furniture Mart in Parkersburg is decorated for the holiday shopping season in the mid-1960s. Begun in the 1930s by Sid Ardman, it was later owned by Leo Levey and Jimmy Applebaum. Sid Ardman was a frequent sponsor of programs on WPAR, the local CBS radio affiliate station. Sid's closed in September 1999. (Courtesy of Paul Borelli and Artcraft Studio.)

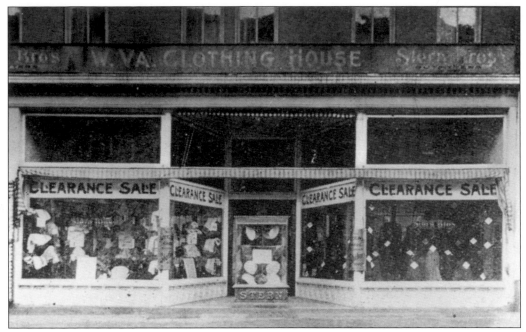

Stern Brothers West Virginia Clothing House, pictured here in 1907, was located at 423–425 Market Street in Parkersburg. A men's and boys' clothing store, the business was established around 1892. (Courtesy of Paul Borelli and Artcraft Studio.)

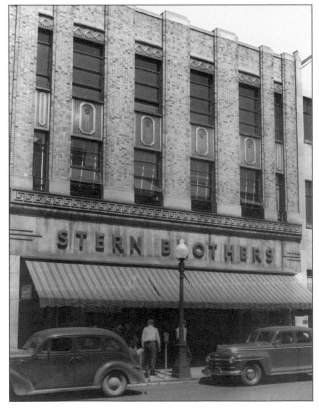

This 1940s view shows the exterior of the newer and larger Stern Brothers store building at 914 Market Street in Parkersburg. The downtown store closed many years ago. When the local mall opened in suburban Vienna, Stern Brothers opened a location there, but it remained open only for a short time. (Courtesy of Paul Borelli and Artcraft Studio.)

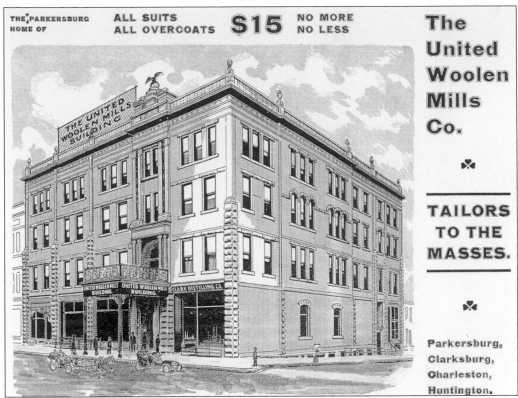

The United Woolen Mills clothing manufacturer and retailer was established by W. A. Hersch and headquartered in Parkersburg on Market Street. The company had retail locations in Clarksburg, Charleston, and Huntington. Hersch was an original founder of B'nai Israel, and the organizational meeting for the new congregation was held at the United Woolen Mills building. An early-1900s advertisement features the Parkersburg headquarters of United Woolen Mills, which closed in 1924. (Courtesy of Paul Borelli and Artcraft Studio.)

Another small Jewish business in 1907 was the tailor shop of Max Waxelbaum High Art Tailor, located at 217 Seventh Street in Parkersburg. (Courtesy of Paul Borelli and Artcraft Studio.)

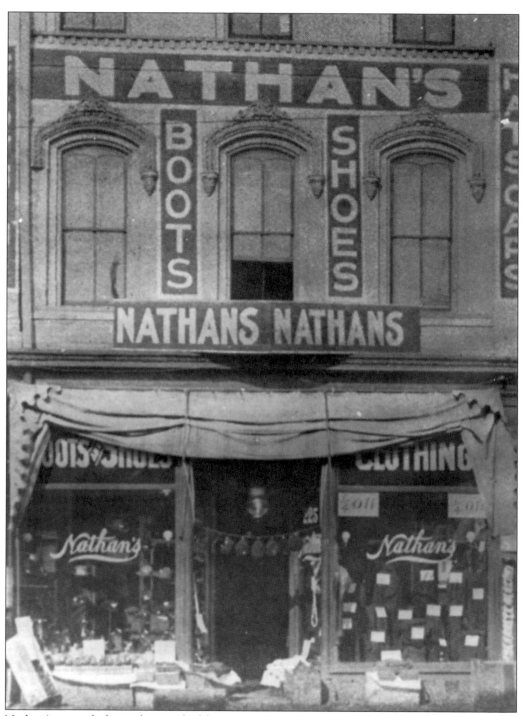

Nathan's was a clothing, shoe, and athletic apparel store located at 225 Ann Street in Parkersburg. The business was established by Benjamin Nathan, who was an early Jewish resident of the city. The Ann Street location, shown here in 1907, was destroyed in a fire following the 1913 flood. Nathan's slogan, "Nathan's Sells It For Less," was well known in the area. (Courtesy of Paul Borelli and Artcraft Studio.)

Seven

WHEELING AND THE
NORTHERN PANHANDLE

Weirton was a well-known steel town for decades, and a strong Jewish community existed there for about 80 years. The first Jewish residents, Samuel Geffner, Baer Rabinovitz, and Ralph Nach, arrived around 1909 and started as pack peddlers and small storekeepers.

The Beth Israel Congregation was established in 1916 and dedicated their synagogue at West Street and Virginia Avenue in 1927. It was a substantial building for the small Jewish community. A chapter of the Zionist Organization of America was organized in Weirton in 1925, a Hadassah chapter was established in 1931, and B'nai B'rith Weirton Lodge 1658 was organized in 1946. Weirton's Jews had a burial ground in nearby Steubenville at Union Cemetery.

Some of the popular Jewish businesses were Greenberger's women's clothing store, Home Furniture, Simon's, Marantz Department Store, Max Nach's Furniture, Al Shaw Jewelers, Weinberg Brothers, and Weisberger's. The Bogorads were physicians in town, and Simon's is still in business today. Beth Israel closed in the 1990s. The building was sold, later partially collapsed, and was demolished.

Wheeling has the oldest organized Jewish community in West Virginia, which began in 1849 with the formation of a Jewish burial society. A Jewish congregation called L'Shem Shomayim was formed soon after. Early Jewish families in Wheeling were the Ballenberg, Bloch, Good, Heyman, Horkheimer, and Sonneborn families. Most became involved in local retailing and also were involved in the production of cigars. Bloch Brothers was famous for Mail Pouch Tobacco. Other early Jewish businesses were the L. S. Good Department Store, Simon Baer and Sons, Bernhardt's, S. Horkheimer's, Kline Brothers, Pollak Tobacco Company, and Sonnenborn's. The Mercantile Club was an early Jewish businessmen's club.

In 1892, the Eoff Street Temple was dedicated and was in use until the Woodsdale Temple was built on Bethany Pike in 1957. Wheeling had B'nai B'rith Lodge 615, the Wheeling Jewish community council, a Workmen's Circle branch, a Hadassah chapter, and Federated Jewish Charities of Wheeling.

The orthodox congregation B'nai Israel, established in 1907, was replaced by another orthodox congregation, Ohav Sholem, established around 1916. Ohav Sholem was still in existence in the 1950s. The Synagogue of Israel was established in the mid-1920s as an orthodox synagogue, but later adopted the conservative form of worship. Their Edgington Lane synagogue was built in 1927. As the Jewish population declined, the Synagogue of Israel merged with the Woodsdale Temple to form Temple Shalom in 1974. Despite having a much smaller Jewish community than in years past, Wheeling has an active and involved Jewish population.

The Ruttenberg's store on Jefferson Avenue in Moundsville was established in the late 1930s. It is a well-known source for casual and western wear and is still family owned and operated. (Courtesy of Bev Yost.)

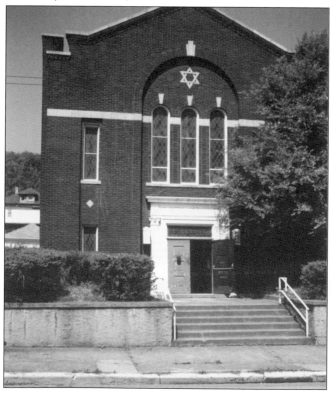

The exterior of the synagogue of Congregation Beth Israel in Weirton is shown in this 1980s photograph, taken when the building was no longer used as a Jewish house of worship. The building later partially collapsed and was then completely torn down. This is the only known photograph of the building exterior. (Courtesy of Weirton Historic Landmarks Commission.)

A 1950s photograph of Main Street in Weirton shows snow-clogged streets after a major snowstorm. Max Nach's Furniture is featured, and further down the street is another Jewish-owned store, the Home Furniture Company. (Courtesy of Weirton Historic Landmarks Commission.)

The Marantz Department Store on Main Street in Weirton was a very popular store in business for many years. This newspaper advertisement is typical of the kind created in the 1950s. (Author's collection.)

BLITHE·SPIRITED FASHIONS FOR

Easter and After!

Ladies' Dresses

Junior Sizes 9 to 15
Misses Sizes 10 to 20
Half Sizes 12½ to 24½

from $8.95

OPEN SATURDAYS FROM
9 A.M. TO 9 P.M. FOR YOUR
SHOPPING CONVENIENCE

MARANTZ
DEPARTMENT STORE
1848 MAIN STREET
PHONE 434 WEIRTON, W. VA.

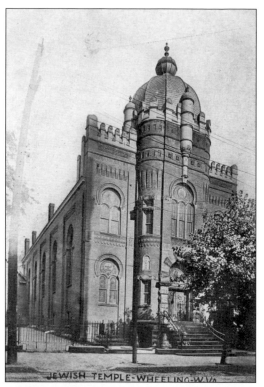

JEWISH TEMPLE-WHEELING-W.VA

Synagogues, like churches, often had postcards made of their buildings. Wheeling's Eoff Street Temple is pictured in this early-1900s postcard. Congregation L'Shem Shomayim's temple was a well-known Moorish Revival landmark in the city. Dedicated in 1892, it was the first permanent home for the congregation. Huntington also dedicated its first permanent synagogue in 1892. These were the first two purpose-built synagogues in the state. The structure was demolished some years after the new Woodsdale Temple was built on Bethany Pike in 1957. (Author's collection.)

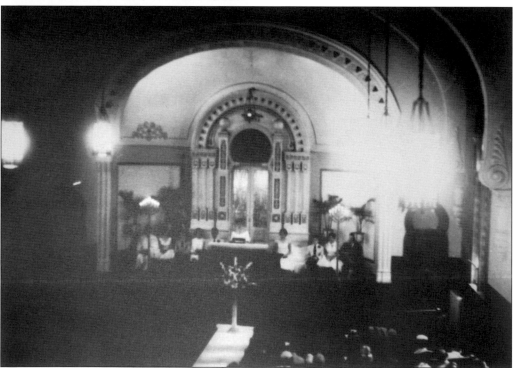

This is a rare interior view of the ornate sanctuary of the Eoff Street Temple in Wheeling. The date of the photograph is unknown. (Courtesy of Arnold Berger.)

The architectural detail of the Eoff Street Temple in Wheeling is depicted in this pen-and-ink sketch, which was used for many years as a temple logo and on letters and publications. (Author's collection.)

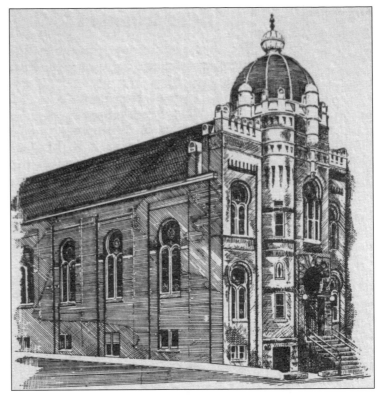

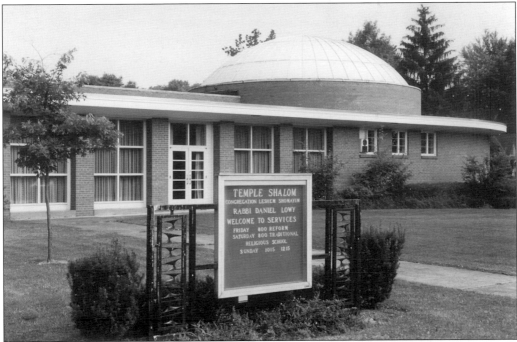

The Mid-Century Modern domed synagogue is a well-recognized structure on Bethany Pike in the Woodsdale section of Wheeling. This 1989 exterior photograph was taken prior to an extensive renovation of the temple. (Author's collection.)

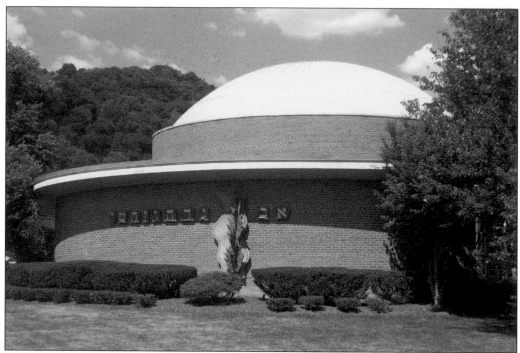

The synagogue building of Temple Shalom was completely renovated and refurbished prior to 2007 and features exterior artwork and beautifully landscaped grounds. (Author's collection.)

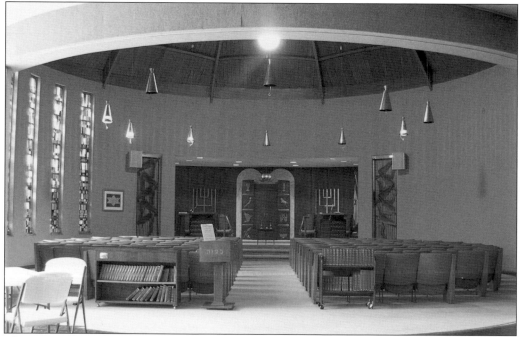

The interior of the domed sanctuary of Temple Shalom features typical Mid-Century Modern styling, with highly polished woods, modern art, and a clean and elegant look. The temple is located in a beautiful residential area and blends in nicely with the surrounding homes. (Author's collection.)

The Mount Wood Jewish Cemetery in Wheeling is located on a bluff overlooking the city. Formed in 1849, the cemetery was the first Jewish organization in the state. It led to the development and growth of the Wheeling Jewish community and later the statewide Jewish community. The cemetery is located adjacent to the Mount Wood Cemetery, which is one of the oldest cemeteries in Wheeling. (Author's collection.)

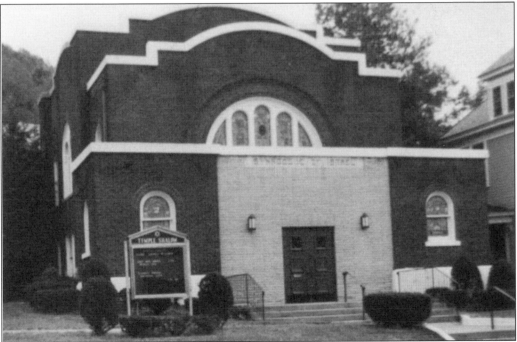

This rare photograph of Wheeling's Synagogue of Israel building on Edgington Lane was taken after the merger between Congregation L'Shem Shomayim and Synagogue of Israel in 1974. The conservative and reform congregations merged to form Temple Shalom and used both synagogue buildings for several years. Temple Shalom now uses the 1950s-style building on Bethany Pike. That temple was known prior to the merger as the Woodsdale Temple and was the successor to the Eoff Street Temple. The Synagogue of Israel building no longer stands. (Author's collection.)

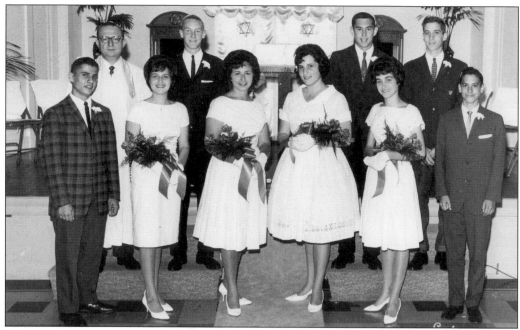

Wheeling's Synagogue of Israel Religious School gathers for their 1963 Confirmation class photograph. Pictured from left to right are (first row) Dennis (?), Lois Klabano (Hanson), Lynne Supovitz (Mayer), Joan Kaplan (Benjamin), Cathy Franklin (Boss), and Louis Sherman; (second row) the rabbi (name unknown), Robert Subit, J. Brylan Perilman, and Jim Joel. (Courtesy of Lynne S. Mayer.)

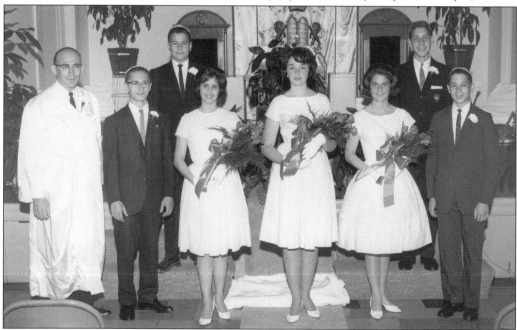

Wheeling's Synagogue of Israel religious school gathers for their 1962 Confirmation class photograph. Pictured from left to right are (first row) the rabbi (name unknown), Victor Wiseman, Anita Bobes (Feldman), Janis Supovitz (Rosenberg), Phyllis Schwartz (Ross), and Mark Bobes; (second row) Evan Pokorney and Rody Guesner. (Courtesy of Lynne S. Mayer.)

Sherry Rosen celebrates her Bat Mitzvah at Wheeling's Synagogue of Israel in 1960. Up to this time, only boys celebrated the coming-of-age rite of passage, at age 13. Sherry Rosen's Bat Mitzvah may have been the first in Wheeling. Today the Bat Mitzvah ceremony for girls is as common as the Bar Mitzvah for boys. (Courtesy of Sherry Rosen.)

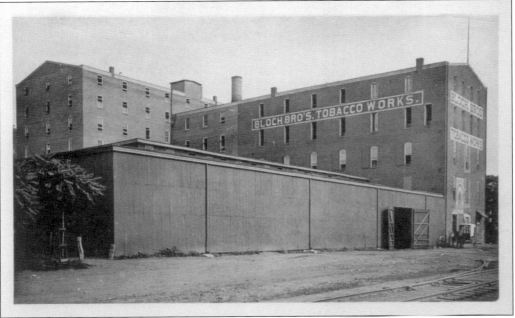

Bloch Brothers Tobacco Works in Wheeling is featured in this early-1900s postcard. Known for making the "Mail Pouch" brand chewing tobacco and cigars, Samuel Bloch, the founder of the company, was one of Wheeling's leading citizens and merchants during the late 1800s and early 1900s. (Courtesy of Ohio County Public Library.)

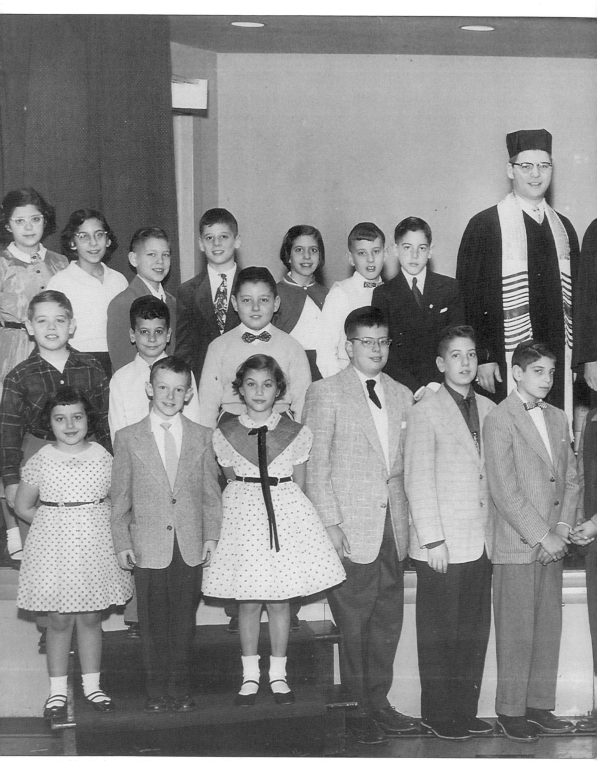

Rabbi Solomon Shoulson and education director Isadore A. Rubenstein are pictured along with the students in this photograph of the 1954 religious school consecration service at the Synagogue

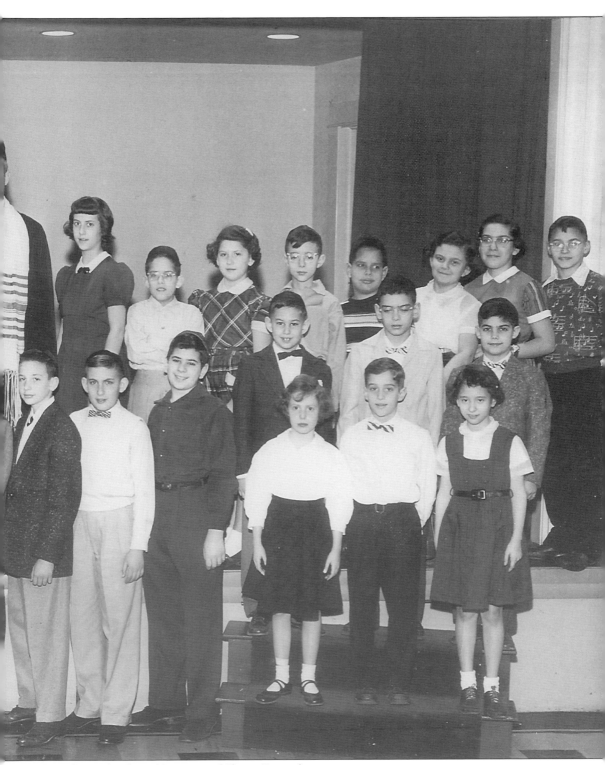

of Israel in Wheeling. (Courtesy of Sherry Rosen.)

Now Comes

Graduating Days

with them thoughts of dress requirements for the occasion.

Blue Serges find great favor and among them are suits specially made for this purpose.

Your Kind of Clothes
in every way

Quality reigns, supreme and style leads always in our clothes for young men.

A Special Showing at
$15.00 and $20.00

MAX CRONE & CO.

Twelfth Street - - Wheeling, W. Va.

Max Crone and Company is featured in an ad from the 1915 issue of Wheeling's high school yearbook. The business was established around 1887 and was located downtown for more than a century. In 2007, Crone's Clothiers, which was no longer a family owned business, moved from downtown to a new retail development on the outskirts of Wheeling, but closed only two years later. (Author's collection.)

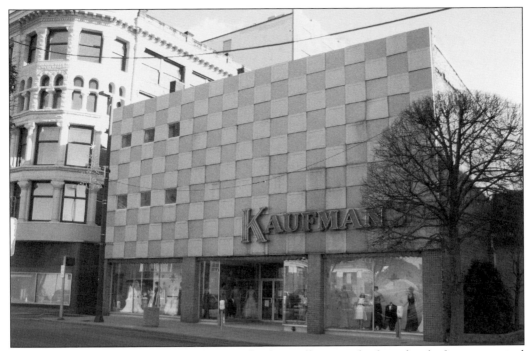

Kaufman's Bridal Superstore in downtown Wheeling still retains the front facade that was typical of stores designed in the 1950s. Established in the early 1900s by Maurice Kaufman, it is one of the largest bridal fashion stores in the country. (Author's collection.)

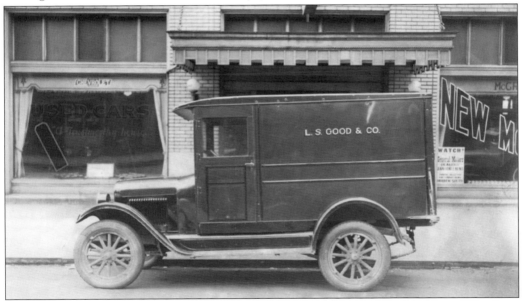

In 1884, German-Jewish immigrant Lee S. Good established a dry goods store in Wheeling. The business was located on Main Street downtown for decades and was an important retail and wholesale establishment. This early view shows a delivery truck used by the company. The Good family became prominent in Wheeling and is involved in a variety of local philanthropic endeavors. The Good Zoo at Oglebay Park was dedicated in memory of Phillip Mayer Good, son of Barbara and Larry Good of Wheeling, who died at age seven. (Courtesy of Linda Fluharty.)

www.arcadiapublishing.com

Discover books about the town where you grew up, the cities where your friends and families live, the town where your parents met, or even that retirement spot you've been dreaming about. Our Web site provides history lovers with exclusive deals, advanced notification about new titles, e-mail alerts of author events, and much more.

Arcadia Publishing, the leading local history publisher in the United States, is committed to making history accessible and meaningful through publishing books that celebrate and preserve the heritage of America's people and places. Consistent with our mission to preserve history on a local level, this book was printed in South Carolina on American-made paper and manufactured entirely in the United States.

This book carries the accredited Forest Stewardship Council (FSC) label and is printed on 100 percent FSC-certified paper. Products carrying the FSC label are independently certified to assure consumers that they come from forests that are managed to meet the social, economic, and ecological needs of present and future generations.

FSC

Mixed Sources

Product group from well-managed forests and other controlled sources

Cert no. SW-COC-001530
www.fsc.org
© 1996 Forest Stewardship Council

Find Your Place in History.